# SINGLE EXPOSURES 2

*Random Observations
on Photography, Art & Creativity*

## Photography & the Creative Process
### A Series by LensWork Publishing

---

*On Being a Photographer*
David Hurn/Magnum
and Bill Jay

*Letting Go of the Camera*
Brooks Jensen

*Single Exposures*
Brooks Jensen

*Single Exposures 2*
Brooks Jensen

*The Best of EndNotes*
*(LensWork #83)*
Bill Jay

To be released in 2010
*Finding an Audience for Your Work*
Brooks Jensen

*Single Exposures 3*
Brooks Jensen

# SINGLE EXPOSURES 2

*Random Observations on
Photography, Art & Creativity*

## Brooks Jensen
Editor of *LensWork*

LensWork Publishing
*2009*

First Edition, First Printing October 2009

ISBN #1-888803-28-2

Published by:
LensWork Publishing, 909 Third Street, Anacortes, WA, 98221-1502 USA

**www.lenswork.com**

To order quantities at discount pricing, please call 1-800-659-2130

Printed in the U.S.A.

# *Thanks, Joe*

*Almost thirty years ago, I attended one of my very first photography workshops. Another of the participants was interested in car-pooling to the remote Oregon coast. I said, "Sure, let's ride together. We can talk photography and while away the drive-time." Little did we know the seeds we'd planted.*

*We became fast friends, and even though Joe Lipka now lives on the opposite side of the United States from me, for twenty years running we still get together once a year and drive somewhere to photograph — talking photography all the way. Joe has heard all the comments in this book ad nauseum and he still goes photographing with me every year. Certainly that must deserve some sort of endurace medal.*

*Skoal — another Henry's for you, my friend.*

# Table of Contents

# INTRODUCTION

This book, like its predecessor, *Single Exposures*, is the result of having clearly set out *not* to write a book. Oh, well.

As the editor of *LensWork*, I'm afforded the opportunity every 60 days to write an *Editor's Comment* in which I can express my ideas, voice my frustrations, offer my counsel, preach from my soapbox, and, if I'm lucky, contribute something of value to the century-old discussions of photography and its role in the life of the creative artist. If I'm really lucky, my readers will find what I've had to say both useful and of interest enough to keep them reading. I've always tried to keep in focus the privilege and responsibility those pages grant me.

There are, however, a bushelful of observations that never make it into the pages of *LensWork*. These are often snippets of conversations I have with photographers and readers, quick observations of things that cross my desk, fleeting thoughts that ping my brain at the most unusual moments but somehow contribute to my understanding of photography and the creative life.

For ten years, such observations accumulated as little scraps of paper and notes gathered in odd places around my office. I never quite knew what to do with these ideas until the Internet provided the perfect opportunity. I learned about *blogging* — in most cases a personal diary or often a running commentary on politics or the news of the day. I realized this was the natural, perfect vehicle to offer my short comments on photography, art, and creativity. The problem, however, lies in my stubby little fingers — all ten of which would like to be skilled typists, but only eight of them actually *are* typists, and extraordinarily bad ones at that.

For the items I contribute to *LensWork*, my "writing" should more accurately be described as "dictating, transcribing, and editing." Whereas most blogs are written (by skilled typists) for reading on the web, it is much more natural for me to create audio recordings. Hence the birth of the *LensWork* "audio blog." On February 26, 2004—the day of my 50th birthday—I recorded my first audio blog and posted it at www.lenswork.com. (Later that fall, Apple introduced the iPod and "podcasting" was born. I can truthfully say that I was podcasting before podcasting was *podcasting*.) I had no intention of ever transcribing these recordings, and certainly no idea of assembling them into a book. I've been surprised, overwhelmed, and little shocked that so many people have asked and encouraged me to do so.

This series of books collectively titled *Single Exposures* is the result. I've now recorded and posted over 560 podcasts (as of October 2009); this book is a lightly edited transcription of the best of #200–325. (By the way, *Single Exposures 3* is now in production and will be released the first quarter of 2010.) We have purposely kept editing to a minimum so that each comment more closely follows the original audio recording. As such, like all such transcriptions where the spoken word is converted for reading, there is a casualness in the text that is purposeful and even conversational. The commentaries here are presented in the same order in which they appeared on the web between July 2005 and December 2006.

Our premise at *LensWork* has always been that photography is, or can be, a way of life; that creativity is more important than technology; that photography is a verb; that images have power and magic to them and deserve more attention than they are generally given. These same themes resonate through the commentaries in this book—which I hope is motivating, inspiring, challenging, thought-provoking, stimulating, and even a bit controversial. These pages definitely contain more questions than answers—a trait consistent with the mind of exploration and creativity that is the most important tool in the life of an artist.

So here you go — truly *random* observations on photography, art, and creativity ...

## Between Chaos and the Predictable

It's fundamental to human nature to want to live in that fine line between control and chaos. It's the way we human beings work — and it's no different in the creation of artwork. If I plop you down in the middle of Yosemite with a large-format camera and you make pictures that are, well, predictable of what a large-format photographer typically does in Yosemite, then those pictures will b e, as we say, predictably boring. At the other end of the spectrum, if I plop you down in Yosemite and you make pictures that don't look *at all* like Yosemite — as a matter of fact, they are totally chaotic and random and have no meaning and no purpose — there is very little to satisfy in that artwork. It's that spot right in the middle — the fine line of creativity — that is neither chaos nor predictable. That's where the great artwork always lies. When the end of the chess game is known, the predictability of it makes us abandon it. When we try to play chess with no rules, the chaos and randomness of it makes it no fun. So what is interesting, both as a creative artist and as a viewer of artwork, is when an individual finds a way to look at something with new eyes but shows us a way to see it that we haven't seen before, so that it's not predictably boring. Similarly, the challenge for us viewers is not to demand from the artist something that we are comfortable with, something that we know how to look at because it is so familiar. The entire world of music is based on the three-chord progression, but how marvelously varied it can be in the hands of those musicians and composers who understand exactly how to bring us to the edge where predictability meets chaos and our attention is held tightly through their creative genius.

## *The Power of Totality*

Edgar Allan Poe, writing in the 1840s, was describing a relatively new written form called the *short story*. He was one of the first to really discuss the concept of what a short story is and what it could be. And of it he said, "Compared to the novel, the short story has strengths. The novel cannot be read at one sitting. It deprives itself, of course, of the immense force derivable from totality." I found this to be a fascinating concept — that the short story is consumed in its totality all at once and there is a power in that that is denied to the novel or to the longer piece of work. It occurs to me that exactly the same thing can be said of television. That's one of the reasons we all like television so much — because you can grasp the totality of the story in one sitting. And that also is the power of photography: its ability to give you a totality *now*, instantaneously, or at least in a very short period of time — in one sitting, even a small group of photographs, a little portfolio, a collection, a small exhibition, even a large exhibition can be consumed at once. And that is a great strength compared to something that *must* be developed over time. That's not to say that the long form of art is not as satisfying, but that each has its own strength and we need to remember this when we're making photographs or photographic projects. That it is that impact of totality derived *now*, derived quickly, that gives it power and strength.

## *Learning by Doing*

When it comes to learning, of course, there are very few substitutes that are better than actually *doing*, and learning while you're doing. I remembered this fundamental lesson of life during these last few weeks when I was working on my new brooksjensenarts.com website. Just *doing* that website taught me a great deal about websites, because it forced me to think very carefully about what websites are, what I wanted mine to be, etc.

And one of the things that I had to conclude when I was looking at websites all across the Internet relative to photography is that most websites function as brochures or catalogs or storefronts. They are a way for us photographers to show our work—usually organized by category with subcategories, etc.—so people can easily find, we hope anyway, an image that they like so that we can then tell them some details that will help them buy. Here's the size, the price, the shipping, etc. So functionally, a web site is a brochure. Well, I didn't want my website to be just a brochure. Sure, I have a section that does that, we all do. But I wanted my website to be something *more* than just a brochure. I wanted it to be an actual distributor of *content*. That meant it wasn't just a reference device that referred to the *real* content, which is my "real photographs." I wanted the website itself to provide something that was itself content. That forced me to think about what content could be on a website. That made me think about publishing and that led me, quite naturally and easily, to the idea of publishing some of my projects as downloadable PDF's. Little books, if you will, in the form of PDFs that you can download—like they're from a library, or something, or a free bookstore anyway—and own and have on your computer and you don't have to buy them or pay for them or anything like that. I didn't want to get into any of that stuff. I just wanted a way to be able to provide something that says, "Here's a photographic project that I did." And that caused me to rethink what my website was going to be. It was a fascinating process that I would have never gone through had I not been involved in the process of putting together my own website. We learn by doing and sometimes the best way to commit to learning is to simply commit to doing.

## *The Importance of Structure*

Really good ideas sometimes have a way of cycling around. I know I've written about this before but I don't think I've talked about it at all in a blog: the idea of the importance of structure,

at least for me. I can only speak for myself in this regard. But the idea is very simply this: when I build around myself some kind of a production *structure*, it really tends to enhance my productivity and my creativity. I know for some people the idea of having structure is limiting but for me it's the skeleton against which I work. For example, if I decide I'm going to have a project that is defined by 100 finished prints—that I've talked about before—then that becomes the structure, and my work simply then is fulfilling the 100 prints. What brought this to mind, here recently, is when I was redoing my brooksjensenarts.com website. I decided that what I wanted to do was have some actual projects, some finished little mini-books, if you will, in the form of PDFs. And once I had that in mind as a structure for what my website was going to be, it suddenly gave me all kinds of impetus, motivation, ideas, creativity, etc. about how I was going to make things to fit that structure. So suddenly, publishing in the form of PDFs became the structure that I was going to work within. Once I had decided that my website was going to be *content*-oriented rather than merely an advertisement for what I'm selling, then I realized that PDFs were going to play an important part of my self-publishing project—a way for me to distribute my work—large projects, small projects, etc. And that is providing a structure for future work that I find very exciting, because now I have a means to create and distribute a whole bunch of photographic ideas that have just been waiting for a vehicle to get out there. Without a structure, however, very little gets accomplished. At least that's the way it works for me.

## *Magnet Rails*

Sometimes it's the really practical ideas that are the most interesting ones, because they overcome some certain hurdle or barrier. Here's a good example: For years I've preached the idea that we should live with our photographs for a while before we cast them out into the world. And the idea would be that I would

go into the darkroom and make a print and then live with it for awhile — put it up on the refrigerator, as it were — and just see how my response to the photograph changes with time, and maybe then go back and reprint the photograph, improving it a little bit as I've had a chance to live with it. Well, it's a nice theory, but I *rarely* did it, if the truth were known. On occasions I would, but more frequently than not, I would go into the darkroom with a preconceived idea of what I wanted an image to look like, I'd create the best, or I should say, *closest* image in reality that I could, based on a reasonable amount of time in the darkroom, and then I'd live with that. I wouldn't go back and reprint it unless it was just plain bad. But most often darkroom work to me has been a certain amount of compromise. I'm sure that a lot of this is because of the sheer logistics and the difficulty of working in the darkroom, and I didn't have a functional way to do it. Well, now I do. I created some metal rails that can go up in my office — I made a whole bunch of them — and found some really strong neodymium magnets that allow me to put up on a wall lots and lots of prints, about fifty or so prints can go up on the wall, and I can live with them for awhile and see them every day and then go back and reprint them as necessary. And isn't it funny how simply having a place to stick twenty or thirty or forty prints and live with them for awhile has made this theory of mine suddenly a reality. Anyway, I thought this was an idea that was worth sharing.

## *Remembering Film*

Well, here was the odd moment of the week. Here in Anacortes (WA) every year on the Fourth of July they have a big town photo. Everybody comes into town who wants to participate, we all line up in the middle of the street, the newspaper people get way up on one of those cherry-picker things so they're way above the crowd, and they take a big panorama picture of everybody who's there and then that gets put in the newspaper. It's a very

small-town kind of thing. And this year Maureen and her sister were holding a flag right down in front of the picture along with a whole bunch of Boy Scouts. When the event was over, the Boy Scouts offered to fold up the flag, and while they did so Maureen started taking some pictures of them. And at the end of the process of folding up the flag, one of the Boy Scouts, who was about ten, came over to Maureen and said, "Gee, were you the one taking pictures?" and she said, "Yeah." And he says, "Can I see them?" And, you know, it dawned on me that it didn't even occur to him that she might have been photographing with film. With film, obviously, she wouldn't have anything to show because you've got to send them to the drugstore and get them processed, etc. But in his mind that possibility didn't even exist—and he's a ten-year-old kid *today*. I got to thinking about what it's going to be like for the kids who will be ten years old ten years from now or twenty years from now. Will they even know what film is? Will they even know about that time when we used to get our family snapshots developed at the drugstore and that you had to buy film, expose film, take it in, get it processed, go back, pick it up, sort through the prints? I'll bet they won't even know what that's like any more than you and I today know what it's like to have to replace the tubes in the radio when they go out.

## *Listening to Johnny Hodges 50 Years Later*

There will, I suppose, come a time when I cease to be amazed by various technologies. But here's as strange a story as I can possibly imagine. In 1951 there was a really terrific saxophone player known as Johnny Hodges and he played for the Duke Ellington band. For a short period he decided to go out on his own, and from 1951 to 1955 he had his own big band playing swing music. I love swing music. Well, there's a radio broadcast out of Ottawa, Canada called *Swing is in the Air* that podcasts their radio programs, which take place every Sunday for about an hour and a half. I downloaded last week's podcast that was

all about Johnny Hodges and his time as a big-band player. I put it onto my MP3 player and was riding my bicycle around town listening to this 1951 recording that had been preserved all these years, podcast over the Internet to my computer, downloaded to my MP3 player, and was now filling my ears and my mind with his absolutely wonderful swing music here in 2005 while I ride my bicycle around. Now the convolutions of that technology and that story are interesting enough, but what's also interesting to me is how it is that his music, now 50 years old, is still being listened to today, by me and lots of others, in a technology completely unknown to him, but we're listening to it because it's such great music. As an artist, what that tells me is that whatever I do needs to be done at the highest possible quality in terms of the content of what I'm doing—the emotion, the power, the feeling—because I have no idea what medium it might be played in or viewed in 50 years from now. But if what I produce is good and worth seeing, it will survive long after the medium has changed.

## *A Harmony of Tones*

I was working on a print earlier this week and was reminded of something I'd read from Fred Picker, that wonderful instructor from the '70s and '80s. Fred once proposed, in one of his now collectible and occasionally infamous Zone Six newsletters, that the tones of a black-and-white photograph have certain inherent harmonies based on the juxtaposition of various gray tones. And he described an exercise, which I think he'd been challenged with by—I don't know, maybe it was Paul Strand, I've forgotten now. But anyway, he printed 100 patches of gray tones in one-percent incremental steps, which he then started putting together and seeing in relationship to one another. And what he discovered was that certain patches of gray went together and created these marvelous harmonic tones and other patches went together and seemed to compete. He likened this kind of

comparison to what happens in music, where a certain set of notes go together and make a harmonious C major chord, for example, and other combinations of notes go together and make a very discordant chord. And his proposal was that exactly the same thing takes place in black-and-white photography. Now I never did the exercise because, quite honestly, it seemed like a lot of work to make those hundred patches and have it all perfectly work out. But the theory of what he talked about made sense. The reason this came to mind is because I was working on an image this last week that had a series of relatively detail-free gray patches that were next to each other. And I found Fred Picker's advice came back to mind because as I printed this with various combinations of dodging and burning I found that, in fact, in certain combinations the print was just harmoniously in tune and in other combinations it wasn't. It's funny that it would be so, but it undeniably was.

## Bach's Motivation

We watched a movie on Johann Sebastian Bach last night; I had ordered this movie specifically because I was interested in learning more about Bach and his creative life. He composed some of my favorite music in the world and I thought it might be interesting to learn more about him. And one of the things that I found interesting was that he died in relative obscurity in 1750 as an almost unknown composer. He was contemporarily famous at the height of his career but late in his career he wasn't so famous. He didn't die a pauper or anything but he certainly wasn't, you know, J.S. Bach as we know him today. His artwork was revived later. The other part about his life that I thought was absolutely fascinating is the fact that his attitude towards his artwork was long-term, that is to say, he did not create his artwork, his music, for his contemporaries, although obviously he composed it and performed it for them to listen to. He didn't create it for them; he created it for the glory of God.

That is to say, he was a very religious, very pious man; he was a capellmeister—a religious music leader in the church—and his faith was great and deep and that's why he did his artwork, for something bigger and greater than himself. Now I'm not saying, by any means, that all artwork needs to be religiously based, but I am saying that it's interesting to me that his need to create artwork, his motivation to create artwork, his production was not in the least based on promoting his career, promoting his sales/marketability, getting the next job, being a big man on campus relative to his contemporaries in the world of organ music or performing. He signed all of his work, at the end, glory be to God, and that was his only reason for producing it. And I may be a bit of an artistic romantic in this sense—certainly not a modernist or postmodernist—that I tend to think that artwork is best when it's produced with a higher cause in mind. Again, I don't mean to imply a higher cause being religious, but something bigger than ourselves; something that has to do not with us as artists but with our relationship and our art's relationship to the bigger, wider world at large.

## *Provenance, Part 1*

I think one of the things I detest most in life is phoniness. And in photography, one of the places this manifests itself is the ridiculousness about numbering editions. Now I know that when most photographers decide that they're going to limit their prints to, say, 250 copies, so it is a limited-edition photograph, they're going to have to number those prints as they produce them. So they go in the darkroom and they produce the first print, and the first one that they finish and matte and get prepared for sale is indicated as 1/250 and that's fine. It indicates that this is number 1 of a limited edition of 250 prints. The problem is they never produce the 250 prints! I know it, you know it, everybody knows it. It's obvious, because 250 copies of a print don't exist. Now I'm sure there are exceptions, and so you could

probably point out to me somebody somewhere who's actually run through an entire edition and sold them all. But in 99.9% of the cases I would attest that the photographer never prints past about copy number 10 or so. As a matter of fact, if they print 10 of a given copy, they're probably pretty doggone lucky. Most of those images never make it past 5. So the game of 1/250 or 2/250 is based on a false premise. Let me be more candid; it's based on a lie. And the lie is that there were 250 copies of this photograph made. I think this is silly. I think it's not true. I think it's *technically* not what's being said, because what's being said is, "I'm not going to make any *more* than 250." But the implication of 1/250 on a print is, subtly, that there are, in fact, 250 copies of this print out in the world. That's precisely what such designation means in the world of limited-edition lithographs or photogravures or linoleum cuts or other works on paper where editioning has been traditionally used. But in photography, 1/250 means something else and to me what it means is a bit phony and I wish photographers wouldn't do this. It has to do with the integrity of the provenance of an image, and I'll have more to say about that in my next comment.

## *Provenance, Part 2*

The provenance of a piece of artwork is of all kinds of importance, not just to the potential buyer. It's not just a marketing thing, but it also has to do with history and the importance of placing photographs in history. The definition of provenance, according to the dictionary, is *the source and ownership history of a work of art or literature.* And this becomes of particular importance with the passage of time. Now those of us who are photographers, I think, have a particularly important responsibility to clarify the provenance of our images, because so many times they do become an important part of the historical record. When a photograph was made or when a print was made is an important thing—not just for photography, not just

for the work of art, but sometimes in the context of the larger history. I can think of simple things like the JFK assassination and the Zepruder film. That piece of photography, if you will, a piece of film, has incredible importance in terms of when it was made and how it was made. Now not all photographs, obviously, are going to have such importance, but the provenance of a photograph can be critical and you and I, as photographers, won't be able to predict or know when—long after we're gone—the provenance of a photograph might be of crucial importance. Therefore, I think it's absolutely necessary that as makers of images we understand how provenance can play an important part and why it's so critical that we be precise and accurate in what we do to indicate the history of our photograph. This is precisely why on my photographs I indicate not only when the negative was made but when the print was made because, as Ansel Adams said, the print being the performance and the negative being the score, the two respective dates of those things can be of critical importance. Rather than edition 1/250 I think it's more accurate in the provenance to explain when the negative was made, when the print was made, and how it was made and handled. And from that point forward, ownership history is an expanding part of the provenance but at least our part of it as the image-maker is complete and accurate and perfectly understandable if we designate our images so. But anything that obscures the actual provenance of the print—for example, when we indicate the negative date without indicating the print date or vice versa, when we indicate what the limit of the edition is but not how many prints we actually made, when we indicate the limit of the edition but we don't indicate that print number 2 might have been made years before print number 5—those kinds of ways of obscuring the true provenance of our photographs does not do anybody any good. Not us, not the collector, and certainly not any sense of history that might be importantly derived from an image of our making.

## *The Art Kit*

So the other day I was in a store and I saw that they were selling an art kit. And it said, *everything you need to be an artist.* And you could buy it in one box as a kit, and the kit had the predictable tubes of paints and cheap paintbrushes and a couple of canvases. And it was an invitation to be something really special, an artist. And this struck me just as odd as could be, for the obvious reason that what it takes to be an artist is not a box of paints and a canvas and a couple of brushes; that's not even what it takes to be a *painter,* let alone an artist. How in this box were they going to package sensitivity and observation and training and experience and life and emotions and passions? Obviously, it was great marketing on their part but it doesn't really have much to do with being an artist. Even stranger is the fact that it's only been fairly recently that the term *artist* is one that one can apply to oneself without seeming gauche. Particularly in Europe, if you called *yourself* an artist it was the most blatant self-aggrandizement—sort of undeserved puffery, as it were. To be an artist was a term that was applied to you by others, but not one that you would ever dream of applying to yourself, any more than today you might give yourself the appellation of doctor. This would seem the height of arrogance. But we've now gone way beyond that, because you don't even have to *pretend* that you have any skill or sensitivity. Now you can just *buy* the title of artist by owning the goods, which of course reminded me of the old bumper sticker wisdom that when you buy a camera you're a photographer but when you buy a piano you own a piano.

## *Typing, Keyboarding, and Photography*

Of course we all know that the word *photography* comes from two roots: *photos* meaning *light* and *graphy* meaning *to write.* Hence, it is *light writing.* Now all of a sudden we have a giant debate going on, because in the world of digital photography,

where we're not using enlargers to make prints but rather inkjet prints and other high-tech mechanical devices, should we call it photography or not? There are those who think that photography is a term that should be reserved for traditional means of photography, where the print is created by writing with light and is therefore true to the dictionary definition. But it occurs to me that all the people who are proposing such ideas, particularly on Internet chat rooms and forums, are all typing their responses into the forum and isn't it interesting that they're doing so with something that is not a *type writer*. A typewriter is a thing that writes type and we all know what it is: a mechanical device that's been around for a long time. Now they're no longer mechanical devices, they're electronic devices that are creating electronic impulses, not mechanical impulses. In fact, they're not even creating them on paper. Should we, therefore, no longer use the term *typing* for what we do on our computer keyboards, but call it something else? I suppose we could call it *keyboarding*, but that would be confusing because that's a term that all the piano players insist be used by those people who are playing piano-like devices that are actually electronic instruments. That's now known as keyboarding. There's no doubt in my mind, anyway, that all of this is a turf war about who gets to use the terms and who gets to not use the terms. Who gets to control the arguments and who doesn't? And it just makes my head spin.

## *Photograph as objet d'art*

I hate to admit it, but my entire life in photography I've been somewhat ambivalent about whether or not a photograph is an objet d'art. It is just a picture — that is to say, is the *content* of a photograph what makes it interesting and makes it artwork or is it the physical piece of paper itself? And in some degree this question surfaces when it comes to presenting a photograph for exhibition or review. If the content of the photograph is everything that matters, then it's good enough to simply put it into a white matte

board, possibly into a frame, hang it on the wall, and say look at the picture without necessarily looking at the artifact. How do signatures, therefore, come into play? Well, the minute you have a particularly famous photographer sign a photograph it becomes something more than simply an image—it becomes an art object. That's when it becomes very interesting how people present it as an art object. Edward Weston used to sign his prints in the lower right-hand corner of the matte board, way down away from the photograph. And so in order to turn his artwork into objects of art, it's necessary to cut a window for the photograph and a window for the signature. And I've always thought if the window wasn't cut for the signature, would it change the photograph? No, obviously not. But if the window *is* cut for the signature, then the signature becomes part of the object and, therefore, it's an object of art. I've on occasion taken my photographs and torn the edges and mounted them in a floating matte. Some people have taken to writing on their photographs or using oil colors to hand-color their photographs. There's a lot of ways that people have applied separate work in order to make a photograph something more than just an image, to turn it into an art object. I find it quite a fuzzy line as to when a photograph becomes an art object and when it's merely an image. And it's a discussion that I waver back and forth on. For a while I want to make all my photographs art objects and for a while I just want them to be images. I don't seem to be able to really fully decide, and that's one of the magical things about photography—it can be *both*. So as creative artists we can decide how we want to choose this thing we've made with the camera. Is it just an image and the entire magic of it is contained in the image itself, or does the physicality of the print contain some of the magic, so it's a true art object that needs to be presented accordingly? It's an interesting debate and I think both answers can be applied successfully and they can both be right.

# *Finishing Work for Exhibition*

Not long ago I was asked to participate in a group exhibition here in Anacortes for our annual Arts Festival. I haven't done one of these things for a long time but I thought it would be really terrific to do so, support the community, love to get some of my work out. And I have a new body of work that I thought I'd show. So it was a perfect opportunity for me to include four or five of my prints in this exhibition. However, it's also been a long time since I've done any framing. Most of my recent projects have either been small handmade artist books or Web devices, PDFs etc. I haven't done any *wall art* for quite awhile. But I prepared the prints and got them ready to put in the frames, and I wasn't at all happy with the way they looked in the frames, because they looked far too simplistic. They weren't very well done. Partly it may be because I'm not a very good framer. But it dawned on me that another reason might be because framing is an art and a skill in itself and that's not what I'm skilled at. I'm a photographer. I'm not a framer. If I really want something framed well I need to go to a professional who has been trained and skilled and has the tools and equipment and experience to do a superb job of framing. Upon having this thought, my first reaction was to feel a bit guilty. And then I got to thinking about it a bit more deeply. I thought, if I were a musician I wouldn't be the person who does the, shall I call it, *packaging* of my recordings. I would make the recordings but I'd have a sound engineer doing some of the technical stuff, and I'd have someone else designing the CD cover and all of that kind of business. If I were a writer I wouldn't be doing the book design and layout. If I were a painter I probably wouldn't even be doing my own framing. So there is a place to separate what we do as working artists from what the finishers do with their skills that prepare our work in a finished, polished presentation. And the more I thought about that, the more I became comfortable with the idea that I think I'll let someone else do the framing.

## *t and Decor*

Once again it's time for the annual Anacortes Arts Festival, here in the little town of Anacortes where I live. This is an annual event, it's a big event for our town, brings in hundred thousand people or so. Lots of food, lots of activity, lots of music, lots and lots of booths full of artists selling their wares. And every year when I attend this festival I find myself thinking again about art and what I observe there. And this year is no exception. I had an overriding thought, which was simply this: "When was it that art and decor became so synonymous?" As I walked up and down the roughly 12 blocks full of art booths, virtually every booth I saw was some kind of decor. Home decor, knickknack decor, bric-a-brac decor, garden decor, office decor, things for the wall, things for the bookshelf, things for the table, cutesy things. Lots of little decorative knickknacks. And they're a lot of fun. I really enjoy them. But is that the only kind of art there is? How come in an event like this I don't see any artwork that is more in line with traditional artworks? That is to say, addressing the big questions of life, you know, "What is the meaning of life?" No religious artwork, for example. No artwork that has to do with interpersonal relations, as it were. No artwork that explores the deep questions that artists have always asked like, "Who am I?" and "Where are we?" and "Why do we exist?" and all of that. Now those are heavy-duty questions and this is just a little art show, so maybe I'm being a bit unfair. But it is interesting to me that so much of what is consideredart today is so decor-oriented. It's as though the purpose of art is to merely decorate our homes or decorate ourselves with what we wear in terms of clothes or jewelry. I've always felt that art was something a little different than that. And of course that could get me dangerously close to the eternal question, "What is art?" which I shall avoid like the plague.

# Beethoven's Example to Us All

Of all the emotions that show up in art, particularly in modern art, I think I tire most readily of angst. I wasn't even aware of this, quite honestly, until the other day when I watched an A&E biography on the life of Beethoven. Now, if anybody had any reason to create artwork that was angst-ridden and depressing, it would be Beethoven. He was the son of a very abusive, heavy-drinking father who physically and mentally abused him. . His mother was what we would classically term a *weak enabler.* He found no solace in his family life whatsoever. His early career as a musician and as a composer was fraught with ups, downs, and difficulties. Of course, he went deaf relatively young in life, which completely eliminated his ability to be a musical performer. He spent his entire life being angry and frustrated and upset. And he had good reason to be angry with life and with. He was famous for his temper, for his outbursts, and for his anger. But when you listen to Beethoven's music that's not what you hear. What comes forth in his music is great joy and great triumph... the victory of the human spirit over the difficulties of life. Of all of the classical music Beethoven's, to me, is the most uplifting. And yet he was an individual who had every reason to make dark, somber, and moody music. I find that fascinating and I wonder, if he were making music today, would he fall in with the common artists of our time who use their angst and their frustrations and their difficulties and their pain and their sorrow in life to fuel their artwork, which ends up being artwork of pain and sorrow and anger and frustration and the problems of life. I may be correctly accused of being, I don't know, a touch Pollyanna, a touch overly optimistic. But Beethoven's work has survived and been celebrated, and I tend to think that the photographers who are so focused on the negative aspects, the depressing aspects, the troublesome aspects of life are the ones whose work *won't* survive. I know there's a lot of debate about this in art circles, but as a human being (as compared to an artist) I find the uplifting art to be the kind I would prefer to surround myself with.

Life is difficult enough as it is without having to celebrate those difficulties in art. I would much rather have my life surrounded by art that helps me endure the difficulties, encourages me in the difficult times, and uplifts me when I need it the most. I'll take Beethoven any day over so much of what passes for photographic artwork today.

## *Photographer as Egotist*

In a workshop I attended years and years ago, David Bayles posed a question which I thought was really interesting. He asked, "Why are all of you so obsessed with making photographs?" And the word *obsessed* really stuck with me. His proposal was that "normal" people—non-neurotic, non-psychotic, non-driven, non-artistically possessed people—are essentially normal because they don't feel any compulsion to make photographs. But all of us who were attending his workshop—all of us who were captivated and captured and driven and motivated and had sacrificed so much to make photographs, in time and money and effort and space in our houses for our darkrooms and equipment and so on—he proposed that we were the ones who were goofy, who were a little bit crazy, that for some reason we're not normal because normal people didn't have the obsession to make photographs like the rest of us. And you know, I'd never thought of it that way. It did give me pause, all those years ago, to ask the question, "Why is it that I'm so motivated to spend so much of my time and energy making photographs?" And the simple answer is that for some reason I feel compelled to share with other people what I see in the world, what I observe in the world. Because, I guess, I operate under the illusion or possibly delusion that other people might be interested in seeing through my eyes. It's a rather egotistical point of view but it is, in essence, the point of view of a photographer who believes that for some reason they have the ability to see the world in a way that others don't, a way that will be valuable to other people who don't see the world that

they do. There is no question that there's an element of egotism in being a photographer, and how strange it is that in order to make the most interesting photographs we egotists have to be able to see the world through others' eyes so we know what it is that they'll be interested in seeing as they view our artwork.

## *The Steinway Artist and the Large-Format Photographer*

For the second year in a row here at the Anacortes Arts Festival, I noticed a fellow who had a booth and referred to himself as a Steinway artist. Now, what he is is a very, very talented and quite enjoyable piano player. He plays light classical music and sells CDs of his music at the festival. But what catches my eye when I see his booth is the terminology *Steinway artist.* As though what he does is specifically associated with Steinway and only Steinway? Otherwise, could he not be an artist doing essentially the same thing on a Baldwin piano? Is it that he can only play his music on a Steinway? It may be simple marketing. It may be that Steinway is a better, classier, more communicative term than piano player, or some such thing. It may be that he has a contract with the Steinway Corporation to promote and advertise their brand of piano relative to his music. I'm not sure what the specific logistics are. But it does, quite honestly, strike me as a bit of an odd terminology. It's as though I were to describe myself as a large-format photographer, as though the fact that I use a large-format camera would make a difference to the people who were seeing the work. Or alternatively, in the big debate of the day, should we call ourselves digital photographers, analog photographers? Do we define ourselves as a type-C colorprint photographer or a type-R color-print photographer, etc? My suspicion is that how the public perceives us is completely different than how we perceive ourselves. And such distinctions as large-format photographer or Steinway artist are distinctions that mean a great deal to us as the person creating

the art and probably seem a bit hairsplitting, perhaps, to the public at large.

## *Steinway, Part 2*

I've received a few e-mails about my comments about the Steinway artist, and a couple of them have been critical of the fact that I appeared either naïve or, at worst, ignorant about what a Steinway artist is, and that it was easily understandable — if I would've simply done a little search on the Internet I could have discovered what a Steinway artist was and then understood the rationale of this pianist using the term Steinway artist in his booth at the Anacortes Arts Festival. These comments, however, precisely make my point: that to this individual being a Steinway artist is a prestigious thing. To the Steinway company it is a prestigious thing. When you're a Steinway artist you are selected based on your talent and skill and rewarded with this appellation. And my question is, whose responsibility is it to communicate that this is a meaningful appellation? That is to say, when there is technical language used in any form of communication with the public, whose responsibility is it to see that the public understands what the technical language implies? The reason I think this is critically important for those of us who are photographers is because we use a great deal of technical language in describing our artwork. For example, a print might be known as a platinum palladium print. Well, if I say platinum palladium print, that means something to you, but I think it may not mean anything at all to the public. It means something about process, it means something about longevity, it means something about the camera that was used, etc. There are all these implications silently communicated via subtext with the term platinum palladium print. And the same can be said of a gelatin silver print or a digital print or cyanotype or anything else. It's our responsibility as artists or as galleries or as publishers to communicate what these terms mean and what they imply so that the public understands.

And that was my criticism of the Steinway artist. The use of language is so important to communicate, but it can also be a barrier to communication when we don't accept the responsibility to make sure that our communications are clear. To adopt the attitude that it's the public's responsibility to pull themselves up by their bootstraps so that they understand the sophisticated language we use is not only asking the public to do something they're not motivated to do, but also to ultimately doom your marketing efforts, your communicative efforts to failure by simply refusing to accept the responsibility that we have to educate the public about what we do.

## Photography and the Hurricane's Devastation

I suspect, like all the rest of you, I've watched the unfolding tragedy in New Orleans as a result of the hurricane with a focused attention. The images on the television have been powerfully gripping, and the amount of human suffering is just heart-wrenching. It's been a very difficult time, I think, for all of us, and, obviously, for those who are living through this tragedy. So in some regards it might seem a little trivial to discuss it in photographic terms, but I must admit I did find myself looking at this human tragedy down there through sort of photographic eyes and the role that photography is playing in the telling of the story and the reportage. For example, somehow the descriptions of what was taking place down there didn't seem totally real, didn't seem nearly as impactful as when the photographs started to become visible in the days following the aftermath. Suddenly we had video, we had still pictures, we had people's faces, and the reality of the visual chaos to add to the descriptions that the newscasters had given us. And the power of those photographs made the tragedy seem so much more devastating, somehow more real than just the mere descriptions of them. That role of photography is just one. I also found myself thinking about a photographic gallery called

A Gallery for Fine Photography that I've been to on a couple of occasions; it's a terrific gallery and it's right in New Orleans. And I found myself wondering what the fate of this particular gallery is, particularly relative to all of the photographs that they house there. Think of the libraries, think of the personal records, think of the flooded banks, and the safe-deposit boxes. Think of the thousands upon thousands of family photo albums and the fate of those memories that are so important of those families. All of these photographic records damaged and destroyed and lost by the hurricane. And finally, I wanted to mention that in *LensWork* #60 we published a portfolio by a New Orleans photographer named Francis Billes, and that we had interviewed Francis not a couple weeks before the hurricane for the Extended issue of *LensWork* #60. And when the hurricane hit with such force our thoughts immediately turned to Francis and we were hoping she was okay. We did send her an e-mail in the hopes that maybe, by chance, she would have access to her e-mail account, and we did hear back from her. Thankfully, she and her family are fine and no one was injured. But at this point she has no idea what has happened to her home. It may be totally destroyed and she probably won't find out for weeks. As a fellow photographer, my heart really went out to her. Not just because of the loss of her home, and her life as she knew it, and memories, etc., but also as an artist. I wondered what happened to all of her photographic archives. What was the fate of her negatives, her darkroom, her equipment? It's a common story that photographers tend to think of their personal life history in the form of their negatives. Oh, that was the year that I was creating the thus-and-so portfolio... Our personal history is defined, to some degree, by the artwork that we've been engaged in throughout our life. And in Francis' case that may be gone because of the devastation of the hurricane. There may be a certain pedantic folly in my thinking of such a human tragedy in terms of something as relatively trivial as photography, but it does occur to me what an important role photography has in the real lives of real human beings, even in the midst of such a tragedy as this.

# Commitment as a Means to Fuel Competence

Maureen and I were having a conversation the other day about a new piece of software that she was interested in learning, and she had to figure out a way to learn this piece of software. She tends not to be very good about reading instruction manuals and learning from formalized how-to books and that kind of thing. And so learning this piece of software had turned out to be a bit of a struggle for her, and she asked me what I might suggest that she do in order to learn it. And I told her something that I have to admit I wasn't even all that conscious of myself until she asked me about it. I told her that the way I tend to learn software is I commit to a project in which the software will be needed. Otherwise, I don't learn the software first, and then do the project. I commit to the project first, and then learning the software simply becomes a means to get to the end. Otherwise, the project provides the motivation for me to learn the software. So I suggested that this is an approach that she might be able to use. And she looked at me and she said, "You know what, you do that with everything." And I hadn't really been conscious of it, but she's right. I have this tendency to jump into things before I know how to do them and then I learn or teach myself how to do them in the process of doing the work. For example, when we started LensWork Publishing we committed to do *LensWork* and I decided that we needed to print the very first issues ourselves as a cost-saving method to try to get our struggling little magazine to survive. I knew absolutely nothing about how to run a printing press. Matter of fact, we went out and bought a printing press and to go along with that I bought the Navy lithographers' manual to teach myself how to run it. So the knowledge about how to do it came as a result of the commitment to do it, not the other way around. It's a method that works for me; it may not work for everybody, I don't know. I can't speak for the rest of the world. But it is an interesting approach that I've used all of my life, even if I did so on a subconscious level.

I thought I'd share it here because, for me, it's almost the best way I learned things.

## *Surrounding Ourselves with Excellence*

I've been in a bit of a sour mood lately, and I couldn't quite put my finger on why. And then it dawned on me that it may be as simple as there's an awful lot of trouble in the world right now. And, of course, being a citizen here in the early days of the 21st century I am, like so many of us, plugged into the 24-hour news cycle. I get news all the time now. Between the Internet, the cable TV, all the magazines, newspapers, television etc., I'm bombarded by all the bad news of the world, and there's just a lot of it right now. There are hurricanes, and tsunami floods, and political strife, and bickering, and the war in Iraq, and terrorism, and you name it. There's plenty of stuff to get us in a sour mood. And I have to admit that that kind of mood affects my sensibilities relative to making artwork. When I'm feeling all tense, and crappy, and argumentative, and pissy I don't feel much like making artwork—I feel like being angry at something, and that's not conducive to the creative life. So, the natural question then becomes, "What is conducive to the creative life?" For me, there's a very specific answer to that that I stumbled onto years and years ago. And that has to do with surrounding myself with excellence. If I find that I watch movies that are just excellent and I listen to really excellent music and read an excellent book, something that's really wonderful and classic and considered at the very top of its art form, if I pull down out of my photography bookshelves some of the best photography in all of history or books of paintings that are inspiring and wonderful and surround myself with excellence, then all of a sudden I'm more motivated to create artwork myself. So being a bit out of sorts here of late, I decided to do exactly that. I have consciously and specifically started listening to Brahms and Beethoven and Miles Davis, and last night we watched a DVD of Diana Krall in Paris. She was just wonder-

ful and the musicianship was fantastic and it was very uplifting. And suddenly, you know, I woke up today and I feel like making some art. Isn't that absolutely interesting, that when we surround ourselves with excellence it promotes excellence in us?

## *The Value of Interviewing People*

As those of you who are participating in the *LensWork Extended* series on CD know, I've been doing an awful lot of interviewing lately of photographers. And I wanted to mention that here because I find something absolutely wonderful about interviewing other creative people. There is a sort of an infectiousness about them, about hearing people talk about their artwork and their creative process in examining some of the ways that they've approached solving creative problems. And I think that's one of the best things that we can offer our readers at *LensWork*. But I want to go one step farther than that. Because I also think it's one of the best things that we artists can do for ourselves is talk to other artists, talk to other people who are not artists but are creative in a completely different field. Go talk to someone who's very creative in business. Go talk to someone who's very creative in public service. Go talk to someone who's really doing wonderful work in some area that's completely unrelated to your area of interest, and interview them with the idea of discovering what it is that makes their excellence work, that builds their enthusiasm. My father-in-law has said that if you want to get people to open up ask them questions about what they do. Very few people are off put by someone who takes an interest in what they do. So being interested in people and their process and their puzzles and their solutions and their ways of going through life and applying their intelligence and creativity to their particular problems can be a most interesting way to learn things that you can bring back to photography that may be you would've never thought about relative to photography until you start to see the connections by listening to other people talk about their

lives and their interests. The value of *doing* interviews, even if you don't have a place to publish them like I do—just the process of interviewing people—can be a most creative act on your part that helps your creativity.

## 1000 Photographs

I'm going to be on shaky ground with this particular commentary because it's likely to sound somewhat like braggadocio, and I really don't intend it to be braggadocio. So please don't misinterpret what I'm about to say here. But I want talk about my print sales and my pricing, because pricing is such a common question that photographers present me with. I've made a big stand about pricing and real-world pricing for photography now for seven or eight years and sell my particular photographs for 20 bucks or so. And I've taken a lot of heat from photographers because I price them so low. But I did notice the other day, as a result of my new website, that I've now sold over a thousand prints at $20, which means, of course, that there are probably at least 998 photographs out there in the world that wouldn't be out there in the world if I had charged $1,000 for my photographs or some gallery price or whatever. Now, in my particular motivation and my particular way of thinking about photography and what it is that I create, I can tell you that there's no question in my mind that I am much more satisfied and much more delighted that I have a thousand photographs in the hands of people who like them enough to pay for them rather than if I'd only had a few photographs in the hands of people who liked them enough to pay *a lot* for them. It's a question of what's important to you. And in my case it's not a contest. I'm absolutely thrilled that a thousand people out there in the world have a Brooks Jensen photograph that I made and that they appreciated. That gives me a certain sense of accomplishment and joy that I was able to bring something to their lives that they appreciate and I could do so in such a way that price did not become a barrier between what it is that

I love to create and what it is that they wanted to own. Like an awful lot of photographers, I suspect I'm one of those people who if I had unlimited means and were able to manufacture, produce, and distribute photographs at no cost, I would, because for me, it's the joy of making photographs that is my reason for being involved in photography. And my distribution strategy, if you will, has been specifically calculated to support my love of making photographs and to help me make as many photographs as I possibly can. Because that's what juices my jets. So I guess this is kind of my way of saying thank you about a thousand times.

## *Tintypes in Print*

In *LensWork* #60 we were delighted to be able to publish the photographic tintypes of Robb Kendrick. They're just absolutely wonderful images of a collection of cowboys that he photographed on 8x10 tintypes using a very old and tedious technique, but they are absolutely marvelous. The reason I thought that I'd mention them here is because of the interesting thing that happens when you translate images from one medium to another. Tintypes have a very specific tonal quality to them and, in particular, the highlights are quite dark compared to a gelatin silver photograph. But, interestingly enough, in the context of seeing one of these images as a tintype, the depressed highlights seem just exactly perfect. They are quite dark, but perfectly natural, in a tintype. And that's the key—what looks natural in that medium? We, of course, had the challenge of translating his images onto the pages of *LensWork*, which is of course not a tintype. It's offset lithography seen in the context of white paper. And so it was necessary, in order to make them look reasonable in that medium, for me to, essentially, lighten all of Kendrick's images quite a bit compared to what you would see in a normal scan. Robb was very happy with the way they came out in *LensWork* in spite of the fact that the images were a little lighter than they were in the tintype, because he understood

that the translation into the new medium required that we alter the images a little bit. But what's also interesting is, even altered, they don't look in *LensWork* in print the way, for example, Stu Levy's landscapes looked in *LensWork* #59. His landscapes had absolutely beautiful, crisp whites. Kendrick's had none. Stu Levy's highlights were 2 or 3 percent. Kendrick's highlights were 20 percent. But still, that made his images look and feel like tintypes. And the more I've worked with photographers who were using different mediums the more I've become aware of how it is that you have to play with the image and alter the tonal characteristics of the image as you translate from one medium to another in order to have something that looks appropriate in each medium.

## *Wright Morris*

If you were to ask most photographers who was the father of modern fine art photography they'd probably mentioned Stieglitz, relative to his influence of the 291 Gallery and *Camera Works*, and, as a photographer, Edward Weston, primarily because of his early work in projects like *California and the West* and his early receipt of a Guggenheim grant in 1937. But there's a photographer who ranks, in my way of thinking, right in with that group of luminaries, who is generally overlooked—not entirely but generally overlooked—and that's Wright Morris. You may not be aware of it, but next year is the 60th anniversary of his seminal book, *The Inhabitants*, which was published just a short 6 years after Weston's *California and the West*. When you think of that in terms of the history and timing of great photography and great photography in publication, that puts Wright Morris right there at the beginning of what you would characterize as fine art, west-coast photography, even though his book is primarily photographs of his family farm in the Midwest. It's an absolutely wonderful book. He did two books as a result of photographing his Uncle Henry's farm, *The Inhabitants*, which was published in

1946, and later a smaller book called *Home Place*. He also received three Guggenheim fellowships to support this photography, in 1942, 1947, and 1954. Again, that puts him amongst the earliest of photographers to receive not only a Guggenheim but to publish such wonderful work in widely marketed books. One of the things that is most interesting to me about Wright Morris is that his primary career was not as a photographer but rather as a novelist, which reminds me of one of my favorite quotes from a friend of mine, Stewart Harvey, who said "The greatest photographs are made by artists who pick up the camera rather than by photographers who decide to make art." That quote may or may not be true, and it may be debatable, but in Wright Morris' case he is definitely an artist, if you can call novelists artists. He is certainly a sensitive soul capable of making interesting artwork in the form of the written word who also had incredible talent when it comes to photography. If you can find a copy of his book *The Inhabitants* (which was reprinted in the '70s, so you don't have to pay a fortune to get one of the initial editions), it's very definitely worth being familiar with his work. Also, there was a wonderful publication that has much better quality reproductions of his work that was published, as I recall, in the '80s, *Photographs and Words*, and a collection of his writings from his entire career, called *Time Pieces*. Wright Morris — a wonderful photographer and someone who should be even more widely well-known and appreciated than he is.

## *Mountains and Pixels*

Lots of people have artwork up in their offices, of course. And the other day I was in someone's office and here was a photograph on the wall that caught my eye. I wasn't there to see photographs, I was there to conduct a little business but, you know, as a photographer I tend to look at people's artwork that's on their walls, particularly if it's photography. And this photograph caught my eye and I admired it and it was an interesting

aerial, color photograph of beautiful Mount Baker, which is the very mountain that I can see right outside my window as I sit here in my office in Anacortes. So this caught my eye. Later when we had conducted our business and our meeting was over, I happened to mention to this fellow that I particularly liked this photograph. And he told me the story about his having photographed this when he was up flying around Mount Baker and made this picture and just loved it. And in his voice and in the way he described both the experience and the photograph itself you could tell that this was an important image for him and was meaningful and he enjoyed having it hanging in his office. So I did what any photographer would normally do, I stepped up and got very close to the image—it was a roughly 10x12" image in a matte board and frame—I stepped up close to the wall to inspect it a little more carefully. And I was absolutely taken aback by the fact that it was severely pixelated. He'd obviously photographed it with a digital camera that didn't have very much resolution. He made the enlargement, and as far as he was concerned he was perfectly happy with it. And you know, as far as I was concerned, it was a perfectly fine photograph when seen from the distance of, you know, ten feet or so when I was sitting at his conference table rather than up close inspecting the print. It was only getting up close to it and seeing that it was severely pixelated that completely changed my impression of the photograph. Isn't that interesting? To me, it suddenly was a flawed product that showed obvious photographic artifacts that were repulsive. To him, it was a meaningful photograph of a meaningful experience in his life. Now if that doesn't demonstrate the difference between how we photographers approach images and how the general public approaches images, I'm not sure I can find a better example. Certainly something for us to keep in mind when we think about how the public relates to our images.

# *Now, Before It's Gone*

I hate it when I know a rule of photography, I know it well, it's ingrained in me, and I forget it, I violate it, and I mess up. And I did that the other day. There was a wonderful building here in town that I've observed for the five years that I've lived in Anacortes and thought, "That is a place I would love to photograph." Because it was just a beautiful-looking location. And they tore it down last week, and I missed it. And I'm not happy with myself, because I let laziness get in the way of doing something that I knew I should have been doing. How many times have I heard this story from photographers and learned this lesson over and over again, not only in their experiences but in my own? When you find something to photograph, photograph it now, because the world never stays the same. As a matter fact, the idea that you can make the world stay the same is ridiculous. Life is movement; life is change. And that shows up in places that we photograph, people that we photograph, experiences that we have as photographers every day. Haven't we all had the experience where we photographed some place or some thing and we really liked what we did and then a few weeks or months or years go by and you find yourself back at that location only to find that it has entirely changed. A building is gone, a street has been paved, a person has died, a tree has grown up, a tree has fallen down, whatever the case may be. And we know that the photograph that we could make today would not be the same, would not be, perhaps, as good as the photograph that we made back then, or, in my case, *should* have made back then had I just remembered the rule of thumb that when you see it, photograph it. Don't wait—it may not be there when you find you're ready to make the picture.

# *Immersion as Composition*

A good friend of mine here in Anacortes, photographer David

Grant Best, who we've published in *LensWork* a couple of times, is involved in a big remodeling project in his house. And as he's been working on that from time to time he needs a break and so he pulls out the camera and has been doing some photography. And he takes plants—leeks from his garden, or onions or other kinds of flowers or plant stems or cuttings—and he makes little still lifes out of them, and he's photographing them and doing some absolutely marvelous work. And I asked him what the backdrop was of one of the still lifes that he showed me. He explained that it was the inside of his wheelbarrow that had some leftover cement mixings in it from when he was buildings some cement to do some footings or something in the construction project. And so he threw these plants down and placed them carefully and started looking at them through the camera and made a wonderful still life. Another one that he had done was constructed on the surface of his table saw. I found all of this absolutely fascinating, and then it dawned on me the other day when I was over at his house that *of course* that's what he would be photographing. That's what's there. His entire property right now is construction and tools and piles of dirt and his garden and all of this stuff and he's making this wonderful artwork out of what's in front of him, which of course reminded me that Ansel Adams made such marvelous and wonderful pictures in Yosemite because *he lived there*. And Josef Sudek did such absolutely fascinating pictures of things like the egg and cheese that he had for lunch because that's what he had for lunch almost every day. You know, we often can work best photographically, creatively, visually when we work with what we are surrounded with, what we're immersed in, rather than traipsing off to some exotic location in the hopes of making art with a capital "A." No. Look at what's around us every day, because there may be the seeds of wonderful artwork right in front of us and it may be just waiting to come out, because as artists we are probably composing our surroundings on a subconscious level anyway because that's what creative people and creative eyes and creative minds do even if they do so on a subconscious level. Why not tap into it?

# *Recovering from Failures of Technology*

At the bottom of the Deschutes River Canyon about 400 feet or so below the cliff where I was standing—oh now, about 20 years ago—at the bottom of that cliff there is an absolutely wonderful Carl Zeiss Tessar lens that used to fit on my view camera... right up until the moment where it slipped out of my fingers and plunged over the edge of the cliff. The reason I reminisce about this long-lost lens is because I had a technological failure this week and it reminded me how much we as photographers are subject to the failure of technology in ways that other artists aren't. Of course, any artist—painters, musicians, sculptors—they all have some form of technology that they use, and their technologies can fail too. An artist's paint can dry out, a musician's guitar string can break, etc. But as photographers, we are *so* dependent on the technology, ours is such a technologically driven pursuit, that when the technology fails it can literally leave us in the dark. A musician whose guitar string breaks can at least continue to sing the song or play it on the remaining five strings as best he can. As photographers, when our technology fails in the field we may be absolutely stuck, which means, of course, that one of our critically important strategies is to anticipate technological failure. Dead batteries, running out of film, lenses getting jammed, tears in the bellows in our view cameras, etc. We need to anticipate all of these kinds of failures before we head out on the kind of photographic excursions where easy repairs are not handled smoothly and quickly. We need to be prepared for all kinds of back-up. For years, for example, I carried extra ground glasses for my monorail view camera just in case the ground glass broke. Now I carry extra batteries, extra micro drives for my digital camera...I even tend, on important trips, to want to carry a second tripod because I had a friend once who told me that his tripod failed when he was out on a trip because one of the legs broke. So as an exercise, now, every time I leave to go out photographing, I just mentally work through a little checklist about what is it that can go wrong and do I have the means to recover

from it in the field. It's a habit I've grown accustomed to now as I head out the door with my camera, and one that has saved my bacon on ever so many excursions.

## *Tea Toning*

Rule number one, of course, is never take coffee or tea or other consumables into the darkroom because you might spill on your prints—which is a rule that I forgot the other day and spilled my coffee right on one of the digital prints that I was working on and it made, obviously, a horrible stain. But it was a very interesting brown stain…and then I remembered the wonderful work that I really relate to and appreciate by the photographer Tom Baril. His wonderful tea-toned images are just spectacular. He takes regular gelatin silver paper and tones it in a bath of tea to literally stain the paper and make beautiful images that have a wonderful brownish hue to them. People have been doing tea toning for hundreds of years in photography, and Tom is one of the contemporary photographers who has sort of rediscovered this technique, and it's really terrific. And as I looked at my coffee-stained photograph and thought about Tom Baril's tea toned photographs I realized instantly that it was now extremely possible to do any kind of background tone that we might want, for those of us who are choosing to do some digital printing. It's perfectly possible to take the paper that we're printing on and run it through the printer a first time, applying nothing but a smooth gradation or tone or texture or pattern or just a tint to it, and then print the photograph on a second pass on top of that. What an interesting, creative possibility that's available to the digital printers that's been available, of course, in the darkroom through tea toning and other such devices for hundreds of years.

# *The Obvious Made Magical*

A number of years ago I was photographing in Wyoming, and I happened to be driving from Jackson Hole north towards Yellowstone. There's a pullout right there where you can overlook the Snake River Canyon. I thought, "Gee, that might be interesting to take a look at," so my photographic partner and I pulled off the road, walked up to the edge of the overview—and there it was, bigger than life, one of the classic photographs by Ansel Adams, his great image, *Tetons and Snake River*. It was right there before us as we stood at the parapet, in front of the stone fence, in the overview from the parking lot.

Years earlier, I'd had exactly the same experience with his image *Clearing Winter Storm*, which was photographed from the overview at Wawona Point.

This is not to say that anybody can make those images, obviously, because thousands and thousands—*millions* of people—have stood at those very places and not made those same photographs. That's an old discussion and we don't need to rehash it. But it *is* interesting to me that it was an *obvious* place to take a picture.

When you stand there and look from those particular places, there's no question. This is not a difficult image to compose, or a difficult image to see. As a matter of fact, I would propose that the viewpoints exist there, as constructed by the highway people, specifically because they recognized that this is a gorgeous, beautiful scene. And millions of people stop at these places, park their cars, get out, walk over there, take a picture of the scene, or take a picture of their family standing in front of the scene because every single one of us would recognize those places as *scenic*, wonderful, beautiful places that should be photographed.

Obviously, what makes Ansel Adams' version of these images so spectacular is the way he interpreted the scene and translated it into actual tones on silver photographic paper. It is not, in these particular cases, that his creative vision was so spectacular because it was, quite honestly, obvious.

This shows, in my way of thinking, the two-edged sword

of artmaking in photography. One edge is when you take the obvious picture and the magic is in the absolutely spectacular execution of the image. And the other side of art is when you make an image that is *not* obvious. That is the kind of creative vision that an artist brings to the mundane and everyday world and translates into something that is spectacular.

These are both perfectly valid methods. They both make perfectly wonderful artwork. But clearly, these are two completely different approaches to making beautiful photographic images.

## How Work Fares with the Passage of Time

In an earlier commentary, I was talking about the work of Wright Morris, whose book *The Inhabitants* is approaching its 60-year anniversary next year. Part of the reason I wanted to draw attention to Wright Morris and to this wonderful work is because of how well it holds up, still, after 60 years. There are many photographers who had considerable fame and reputation during their age — and even today will show up in a lot of the histories of photography — whose work, when I go back and look at it, now just doesn't seem to hold up very well. It begins to look dated and in some cases even trite, very definitely a product of its time. And my appreciation of the work is influenced by what I see as its not having held up very well over the years.

In contrast, the photographs that Wright Morris made in the 1940s on his Uncle Harry's farm — that are in *The Inhabitants* and *Home Place* — hold up incredibly well today. They are absolutely marvelous photographs. I can't help but think that this is one of the tests of really significant and wonderful artwork — how well it holds up over time.

It's a very interesting exercise to go back to your photography books in your library, or the public library, and look at books of photographs or monographs that are now 20, 30, or 40 years old. See if they still impress you the way they did back then or if they impress you at all today (if you're new to photography).

Or do they look like something that is passé and trite and, as I say, a product of their times. It's the photographers like Wright Morris, whose work continues to thrill me to this day, who I find myself going back to and reflexively using the term "Master of Photography"—because their incredible vision still survives after all these years.

## *The Right Tool*

Every job has a tool.

If you don't believe this, go to Home Depot and try to buy a hammer. I was there just the other day and found *eighteen* different kinds of hammers. They all looked very similar to what I think of as a hammer, but they're specialty hammers of every kind. They all do different things with different jobs. It's important, I guess, these days, in order to be efficient, to use the right hammer for the right job.

Well, if it's true in construction, it's certainly equally true in photography. I lived in Oregon for 35 years, and in 35 years I spent a lot of time on the Oregon coast attempting to make photographs there of the beautiful scenery. It is spectacular. But during those years I lived in Oregon and photographed, I used, almost exclusively, a monorail view camera—which on the Oregon coast doubles as a *sail*. The tiniest little puff of wind would make this camera not very functional. And there's a lot of wind on the Oregon coast.

So, in all the trips, and all the attempts to photograph at the Oregon coast, I do not have a single decent photograph from the coast—until at last, a few weeks ago, when I was there on vacation. I happened to be there with my digital camera. One of the things that I found interesting about working with this camera at the coast was that I can dart in and out of the car, avoid the cloudbursts, and photograph quickly. And with a good tripod and a heavy weight suspended underneath the tripod,

I could stabilize this lightweight camera against the wind and get sharp pictures.

Now, I don't intend this to be a *digital versus analog* comment at all. What I intend to say is that *finding the right tool sometimes makes the job a lot easier.* In this particular case, being at the coast in the wind, in some rough weather, I was able to make photographs successfully with a different tool than I had ever used before. It's a fairly simple lesson, but it's one I think I'll try to remember the next time I'm not successful with whatever tool I have at hand.

## October Seas Folio, Part 1

I'm involved in a new photographic project. I'm actually about three quarters of the way through, so I'm in mid-project. I've had several observations that I thought I would share. I'll do so over the next several podcasts.

Now the nature of this project is, quite honestly, an experimental test. I can best explain it by letting you know that I've recently concluded reading three roughly 800-page novels. I've about had it with big things for a while, and I wanted to get involved in some short things. So I'm reading a bunch of short stories. I decided to experiment photographically, creatively, with the nature of a short project. That is to say, specifically, could I produce a folio of work in about three or four days' worth of photographing and then a very short period time printing?

I'm producing this based on a visit that I made with a few friends of mine down to the Oregon coast the weekend before last—specifically, the final weekend in October of 2005. I picked up a friend at the airport in Portland on Thursday, about midday. We drove to the Oregon coast and photographed Thursday, late in the day, most of the day Friday, Saturday, and about half of Sunday. Then we headed out.

I have several observations about this photographic experience. First, I made roughly 800 exposures with my digital camera

during that period of time. I selected about 14 images, something like that, that I wanted to start playing around with. And as it's turned out, I've ended up with 12 good prints out of that experience that are going to go into a folio. It's going to end up being a little body of work of 12 specific images.

Here's one of the things that's interesting that I noticed about this. I did the proofs, put them up on my wall, and started looking at them. With each individual print, while I was doing it, I was very enthusiastic about it. I was Photoshopping it a little bit, and printing it, and doing variations in dodging and burning—all that stuff that you normally do to tweak an image to make it great. Each individual print ended up being great when I had finished it. Then I put them all up on the wall, the finished 12 proofs, ready to "live with them" for a few days and examine over a period of time in different light, etc.

I ended up liking some more than others. As I showed them to Maureen, she decided she liked some more than she liked others, and a couple of friends came by, and I showed the prints to them. Everybody has their favorites, and *everybody's favorites are different*—which is not unexpected.

But here is the observation—at least the first observation—from the production of this little folio: any time you put together a collection of prints, there will—by the nature of the way human beings work in life—there will be a *ranking* that takes place. Some people will like these, some people will like those. We will all, individually, take a look at a dozen prints and say, "These are my favorite three or four, these are in the middle, these in my least favorite." That kind of ranking process appears to me to be absolutely basic and fundamental to human nature.

My point is: *this has nothing to do with putting together a portfolio of prints.* Because everybody's ranking will be different, you should not limit yourself, or let that unduly influence you, relative to which images go into the portfolio. A portfolio is a coherent body of work that consists of discrete individual images that you decide, as an artist, are the important components

that need to be included. Just understand that the ranking pro-
cess is unavoidable, because it's the way we human beings tend
to think.

I'll have more comments about this portfolio in my next com-
mentary.

## *October Seas Folio, Part 2*

I'm spending a little time on several podcasts here in a row
talking about my new folio, called *October Seas,* that I am produc-
ing in just a very short period of time, as an experiment.

My next comment has to do with one particular image.
One of the photographs that I wanted to make in this portfolio
down on the Oregon coast had to do with this silvery look of
the ocean as it works against the light coming through a cloud-
filtered sky. There is a silvery look to the sea that I wanted to
capture. I'd actually experimented with this image about ten
years ago, trying to photograph it on Polaroid positive/negative
film—but I was not very successful with it. I've had that image
in the back of my mind now for lo these many years. Here was
my opportunity to try it again.

I was on the coast, on the rocks, with my camera pointed
towards the filtered sun on the perfect day. It couldn't have been
better! I decided that what was necessary was to get just exactly
the right kind of wave motion and action in order to make this
print perfect. Well, with a digital camera, it became relatively
easy for me to just take lots, and lots, *and lots,* of exposures over
the period of about 90 minutes, trying to get the perfect combi-
nation of waves. This is the kind of thing that I would never have
done with a view camera, by the way, because of the expense of
sheet film, and the hassle, etc. But this was the perfect tool for
the perfect project.

I'd been there about 90 minutes, photographing various com-
binations of wave, and light, and the sun dancing in and out
of clouds, etc. I was about to pack up, but decided, "You know,

I think I'll stay for just a couple more," because the light was particularly good. At that moment, off from my right, flew in this flock of sea birds. They kind of looked like plovers, something small like that. I don't think they were plovers, but I'm not sure. They landed on the rock that was just on the right side of my composition. A wave came crashing in—boom—big spray, big water—the birds took off—and I went *click*, just like that. It was the perfect moment. I happened to be pre-focused. I happened to have the camera on the tripod. I happened to have the perfect exposure dialed up. It happened to be 1/3000 of a second, and the birds were caught in flight. They are absolutely tack-sharp. It's a marvelous photograph, and I've absolutely fallen in love with this image. But I would never have been able to capture this image had I lost patience.

Sometimes—this is the great lesson here—photography requires the most incredible patience—and this, from the kind of art form where you can make an image in 1/3000th of a second! It's an odd anomaly about patience and instantaneous exposures, but they do go hand in hand. And I am so glad that I remembered that lesson on this particular exposure.

Now having said that, the reason I think patience is so important is because *luck*—there is no question about it—luck favors the patient photographer. I don't know about you, but I'll take all the lucky ones I can get.

## October Seas Folio, Part 3

I've been talking in the last couple podcasts about this folio project I'm doing, called *October Seas*, as a little bit of an experiment. Here's another observation about this that I thought I'd pass along.

This particular portfolio, as I mentioned, has 12 individual images. Each one I've created by looking at the image and making it, individually, one at a time, the very best image I could.

Concentrating hard on each individual image has taken me several days' worth of work to work.

After I completed all 12 proofs — and made the best photograph I could from that particular image — I took the 12 proofs put them up on the wall and looked at them for the first time *as a group*. This started me thinking about this project as a group, partly because I wanted to work on the title and that kind of thing. I was fascinated that when I put them on the wall as a group, several of the images didn't fit — not subject-wise, not from a composition or a selection-of-subject point of view, but from a *palette* point of view. That is to say, the portfolio itself had developed into a certain kind of palette. There was a "look" to the images that was consistent with nine of the twelve, and three of the images were not the same tonal range. They didn't have that same palette. They were lovely as they were, but they didn't fit with the rest of the images.

So, I had a decision to make. Should I abandon these images and cut the portfolio down to the nine that fit together? Or should I try to tweak the images, so that their palette fit the rest of the portfolio? It's an interesting dilemma because tweaking the image might make a compromise to that image that would make it not as good, perhaps, as it could be if you were presenting it all by itself. I wasn't sure what to do. I decided to go ahead and experiment with it. I tweaked the three images just subtly so that their palette and general tonality would match the rest of the images in the folio, and replaced the original three on my preview board so that I could take a look at how they now felt with their new tonalities. They looked absolutely spectacular! As a matter fact, they looked better than the original prints.

I'm beginning to wonder if maybe, sometimes, working on an individual image gets us so involved with the forest that we can't see the trees — or, in this case, so involved with the individual trees that we can't see the forest. The images that I've ended up with on those three that originally didn't fit are each individually *better* now that I've made them fit the folio. I think that's an interesting thing. I would have never predicted this when I set

out to do the project. But in fact, that's the case. It's an interesting note about printing, and I'm now finding myself wondering if some of the images I've done in the past might be seen differently by me and printed differently by me, if I was working with them in the context of a larger project.

## *October Seas Folio, Part 4*

With some consistency over the years, I've had photographers tell me that one of the most difficult things they have to do with their prints is to title them — which may explain why so many photographic prints carry the dubious title of *Untitled*.

I've always found that a somewhat odd title for a print. After all, *Untitled* is a title! It's just that it's everybody else's title, and is a non-title...but I digress.

I've always thought titles are very important in the artwork and, as a matter of fact, are actually part of the artwork. They influence the way people will see and respond to the artwork. As I've said before, if *Migrant Mother* by Dorothea Lange were instead titled *Waiting for the Returning Soldier*, we would interpret that print in an entirely different way. The title *Migrant Mother* influences the way we see the print.

Well, with this portfolio I've been discussing in the last several podcasts, it came time to come up with the title for the project. I'd had no title going into the project, so I had to invent one on the backside, which is most typically the case for me. I'm generally not the kind of person who comes up with a title first, and then goes and does the work afterwards. I usually do the work first, and then find the titles later.

How does that happen? There are probably lots of different ways that people come up with titles for their work, but for me I let the work title itself. For this particular folio, for example, once I had all of the images lined up, looking at the proofs. I just sat and looked at them and listened,becoming still and sensitive, I hope, to what the images were attempting to communicate to

me. During that process, I came up with maybe 60 or 70 different titles, and in every case, once the title had popped into mind, I'd look at it, massage the words in the title, compare it to the prints, and most often the title just didn't work. It fell apart. It was like bad dodging or burning in a print. It was not conducive to *enhancing* the work. It, instead, was trite, or trivial, or somehow silly.

Often, I begin the process by simply writing down a lot of different words that pop into my brain as I'm looking at the prints. In this case I thought of the sky, and the sea, and the wind, but I also thought about life, and about cycles of life, and rain. There was a lengthy list of words. Eventually, working with these words, and with the emotions that the prints were giving to me, I finally found the title that the work was trying to tell me. I mean to use that language quite specifically. I think the work wants to title itself, and my job is not to *invent* the title, but rather to *hear* the title.

So the title of the folio is *October Seas: Sky, Breath, Surf.* And I use the word "breath" specifically because that's what these prints felt like to me. They felt like the breath of the earth, the cycle of life, and even though part of me felt it was a bit obtuse, and maybe even a bit pretentious, it's what the prints said to me, so that's what I decided to call it.

## Passion in the Old and New Media

As many of you are probably aware, we closed the *LensWork* darkroom earlier this year because of some the challenges of the digital negative technology we were using to create *LensWork Special Edition Prints*. Recently a *LensWork* reader wrote me about this issue, about the digital and analog transition and controversy, and the debate between digital photography and analog photography. Although this is a debate that's not likely to be resolved with such a simple thing as a podcast, it is something that

I think is so important to photography today that from time to time I don't mind bringing it up in this podcast.

Even though some of you probably already thought this through—some of you have already staked your turf, some of you are very pro-digital; some of you are very anti-digital; some of you are pro-analog; some are anti-analog—my idea here is not to advocate one position or another, but rather to add to the discussion. I'd like to do so by reading the e-mail exchange that I've had with this reader. She writes in response to an e-mail we sent out about the closing of the *LensWork* darkroom, "I am heartsick. If all of us give in to this digital craze, there will be no more of the photography many of us love. That Zen-like experience of creating an image, and not pushing a button. I love the gelatin silver print. This is what I do as an artist. I am sick over everyone running out and buying digital everything. This is an art form, as much as painting, or pottery, and thus, a lifelong passion. I majored in fine art photography and have diligently, over the years, continued attending workshops, mastering printing techniques and toning to create my own style, my own voice. It is what I do. And each time I see yet another long-standing symbol, such as *LensWork*, fall to the digital craze, I am crest-fallen."

Now there is no doubt in my mind that she writes this with heartfelt passion. She obviously is passionate about her images and her photography. It's to that element of passion that I wanted to address my comments to her and in this podcast. I wrote back:

"As to passion, said plainly, my passion for photography and my images has done nothing but increase as I have embraced digital photography for my own personal work. I am more excited about making images now than I have been for, quite literally, decades. There is no doubt that this is directly attributable to my ability to make images that more precisely and more easily express my personal vision. I was competent in the darkroom, even proficient. I did not, however, relish the hours of drudgery mixing chemistry, making test-strips, waiting interminably for the print to come up in the developer, fixing and washing, drying

and spotting, flattening and trimming. And this says nothing of the hours of my life I've spent washing trays, washing developing tanks, etc. To me, all of this was a drudgery beyond belief. None of it, not one moment of it, had anything to do with my passion for looking at and making images, or for sharing my images with others. With the technology of the day it was, however, necessary, and I endured it. I did not like it. My creative life was 2% creative and 98% pain in the darkroom. Now, with today's digital camera and a digital printer, my limited creative time is spent almost entirely in the creative process instead of fighting the technology to get the image I want.

"Here is a practical example: Consider the count of seconds spent working on one's creative vision in the darkroom. For me, the creative part of the darkroom was the few seconds I spent looking at an image post-processing, deciding what creatively to do next, reacting to the print as it was made, feeling the emotions it contained, and then deciding what dodging or burning, what cropping or contrast changes, what bleaching or flashing to do next to enhance the print. I would look at an image for a short time, say 30 seconds, maybe a minute, and then it would take me 12 minutes to execute the next print, to load the paper in the easel, reset the timer, make the exposure, move the paper to the developer, agitate during the four-minute development, stop and fix for five minutes, pull the wet print to the viewing easel, turn on a light, wait for my eyes to adjust, and then re-enter the creative zone for another 30 seconds or so, to see if this print was closer to my vision. My time in darkroom printing was literally 96% fussing with technology and 4% looking at an image with my creative vision. This does not include setting up at the beginning of a darkroom session nor cleaning up at the end. It does not include any time for developing film, which would usually require an entire weekend of work for every weekend I spent out photographing. Hours and hours and hours of fussing with technology for a few minutes looking creatively at images.

"Compare all that to my creative work today. I return from photographing and upload the images to my computer in

about 15 minutes. I archive the digital files, another 10 minutes. I'm into Photoshop and working on prints within a half an hour. And then, with each image I work on, I can look at it on the computer screen, study it, decide what I want to do with it, and within seconds, I'm looking at the new image. If I don't like it, I just "undo." If I want to experiment down a test path, I make a copy of the digital file and jump in instantly.

"My creative life now is just the opposite of my life in the darkroom. I now spend 96% of my creative time looking at, and playing with, my creative vision, and only 4% waiting for technology to show me what I'm creating—just the opposite of my darkroom days.

"Some people simply do not like sitting in front of their computer. To them, it doesn't feel like art-making. I understand that, and I do have empathy for those who are not computer comfortable. I am. I would much rather create images in the light, with my cat on my lap, without the smell of fixer, or the white noise of the darkroom exhaust fan. I would much rather spend my creative time working on an image that makes my artistic vision become real *one time*, and then have the ability to print it repeatedly for all those who would like to own it, rather than to have to re-create the same artistic vision over and over for every copy of the print I make.

"So, my passion for photography has increased because of the new technology. I've made more photographs in the last year than in the last ten years combined. I've distributed into the world, either by giving them away or selling them, more images in the past year than in the last 35 years combined, all because of the new technology. Is the technology right for you? Sound like it's not. But be careful of condemning the technology just because it's not a good fit for your own creative process. For some of us, it's the solution we've been waiting and preparing for our whole life."

So that was the e-mail I sent. For those of you who are absolutely passionate about analog photography, I applaud you.

That's wonderful. You found your creative medium: stick with it and don't be persuaded to experiment with digital if it's not a good fit. And for those of you who have embraced the digital technology, then great! Maybe you, like me, have found a technology that's a better fit for your creative vision. The point is, for those of us who are photographers, **matching the medium we choose to create in with our creative vision and our process is what counts**. And whatever process and creative medium fuels your passion and your creative vision, that's the right medium for you.

## *Print Quality, Reverse Engineering, and the Limits of Digital Cameras*

Since in my last podcast I had some complimentary things to say about the digital workflow and how I enjoy digital printing as compared to the drudgery of the wet darkroom, I should, I suppose, mention a few of the downsides.

For those of you, particularly here during the Christmas holidays, who are getting all excited about digital photography, there are a couple of things that you might want to think about before you get too oversold, I guess I might say, on all the digital hype that's now starting to show up in all the advertising, and all the photographic press. There are some very serious limitations to digital photography — as it exists now, anyway, in December of 2005 — that I've discovered and that I want to share, not the least of which is *print size*. When it comes to print size, everything, in my way of thinking anyway, is always about print quality. What is the quality of the final print? I've always been an advocate of large-format photography all my photographic life, because you just can't get the same kind of quality in a smaller camera that you can in the larger camera — assuming that by *quality* you mean sharpness, detail, smooth tonalities, grainless images, that absolutely wonderful feeling that you're looking at the real world instead of looking at a photograph. Now, those of

you who are 35mm photographers and love Rodinol and grainy pictures, I can appreciate that aesthetic. Let's set that aside for just a minute, because I want to focus here on images that have incredible detail and smoothness of tonality.

The question is, *What can you do with the digital camera that creates that look and that feel?* That's where the first and most tangible limitation of digital photography comes in—you simply cannot make a print with a digital camera that's as big as you can with a film camera. It cannot be done with today's technology. I limit my prints pretty much to 8x10s. Maybe I can go to 11x14, but probably not. With a 4x5 camera, or particularly an 8x10 camera, there are no such limitations in print size. In essence, what I'm encouraging you to think about is a bit of reverse engineering *from* where you want to end up, and whether or not a digital tool is going to be good enough for you—or whether or not you'll have to shoot it on the better-quality film.

If you want to make 20x24 gelatin silver, gorgeous, black-and-white landscapes (à la Ansel Adams), don't be fooled into thinking that you can get that result with a digital camera—or, for that matter, with the 35mm film camera. It can't be done. On the other hand, if what you're interested in doing is 8x10 images, and that's as big as you need to make them, then you might be able to get by with a digital camera. Of course, that depends on the whole question of print quality. Do you want to print on silver paper because of its aesthetic? Can you print on inkjet paper with its aesthetic? That's another whole issue about quality.

I want you to recognize that despite what a lot of the advertisers might be trying to convince you of, if you're trying to make fine art photographs that compete with the history and the legacy of what it is that has been handed to us by those great photographers who've come before us, you will have to recognize the limitations of these new tools. They may not work at all for what it is that you want to end up with. Reverse engineering is the key, and be absolutely disciplined about what the final product is that you want

to end up with, and not too overly prejudiced with what the tool is that you want to start with.

## *The Thank-You You Deserve*

It's been a while since I said "Thank you" to all of you who have listened to these podcasts. I'm remiss in not being more diligent in showing my appreciation. I really mean that sincerely.

I was thinking the other day of the relationship between photographer and audience. I remember that there is no more precious gift that someone can give to an artist than the devotion of their attention. This is even more true today, when there's so much clamoring for our attention. Life is so busy, and media is so prevalent, multi-tasking so universal, that to just get someone's attention is a gift they've given us that we really should cherish. When someone says, "I'm going to take time in my busy life, my hectic life, to look at your artwork," what they're really saying is that for a few minutes, or even just a few moments, looking at your artwork is the most important thing they have to do. What an incredible gift that is!

What made me think of this was that I was spending some time wandering around through some used bookstores over the holidays. Every time I'm in a bookstore, I see shelves and shelves of books that are the labors of people asserting their creativity and plying their arts, in the form of these books, published and read contemporarily. Now they exist in the limbo of history. They're residing on the shelves, just waiting for someone to come pick them up. It's almost as though they're calling out to me and begging somehow, "Please, read me!" The authors are speaking through these books. But now, particularly with older books, it seems no one reads them. The stories are untold, the pages are closed. What a gift it is to that author, or poet, or photographer, to pick up their book and let them have control of your mind, and your perceptions, and your thoughts for a few minutes.

So when you listen to my podcasts, or read my books, or look at my photographs, I'd like you to know how thankful I am that you are giving me the gift of your attention, and that your gift is acknowledged and appreciated. So thanks, and have a happy New Year.

## *Why I Don't Mat My Own Work*

I was asked by someone who had purchased one of my *Brooks Jensen Arts* photographs why it is that I don't provide them matted anymore.

I've thought about this a great deal. Quite honestly, I made the decision that I would stop matting my own photographs for one very simple reason. I produce my photographs to be as good a quality image as I possibly can. I like to think of myself as a person who has a reasonable amount of talent and skill —photographically—which is a little difficult for me to say, being a Scandinavian. We're taught to be humble. But I do like to think that I'm producing photographs at a professional level, to the best of my abilities, and as good as the standards are in fine art photography.

So, with that as my objective, the question is: why would I take my exquisitely produced photograph and put it in what I could characterize at best as an amateur mat board? I am not a skilled framer. I haven't gone to framing school; I haven't studied it; it's not my passion; I don't have the tools; I don't have a studio set aside for framing and matting. And there are people who do! They do exquisite jobs of matting artwork, far beyond what I could ever do with amateur tools.

In this regard, I take my lesson from the world of painting. Painters are often not the people who frame their finished paintings. They rely on professional framers to do that job. Painters paint, framers frame. I think it's a fine idea. Photographers ought to photograph and let specialists — professionals who are skilled, talented artisans — do the matting and framing

for us so that we can present our work with the same kind of exquisite skill with which we make it.

My thinking is quite simply that if I'm going to take my beautifully crafted photograph and put it in an amateur mat that I would cut—a simple four-ply, beveled window, white mat board sort of thing—it's a very amateur approach. My task as a photographer is to make the photographs, and let the pros do the work of the pros, while I try to focus my energies on the work that only I can do, creating my artistic vision in the form of finished photographs.

What about protecting, storing, and handling the work? Well, I've just simply come up with alternative ways to do that. Instead of keeping my work pristine by putting it in a mat board, I keep it pristine by putting it in a plastic bag, with a good solid backerboard to protect it dimensionally, before I store it. Quite honestly, I sell them and ship them that way. When the final matting and framing professional gets hold of the work, it has not already been affixed with dry-mount tissue, or some such other material, onto a mat board which simply has to be discarded and replaced by their quality work.

This is clearly a different approach than the traditional West Coast school of photography, where we were taught to mat and frame our own prints in pristine white mat boards. It works for me, and it gives, in the end, a better presentation for my photographs when they're handled by professional matters and framers.

## Six Hundred Pounds of Equipment

I suppose this commentary falls in the category of "aren't we glad things are little easier today than they used to be."

Of course, the long-term history of the mechanics of cameras and manufacturing has been to make the creation of images easier and easier. We could go back to how complicated and convoluted it was to make wet-plate photographs back in the days when photographers used to have to carry their darkroom tents

with them. I'm not speaking from personal experience, obviously, but it was done back in photography's history.

What brought all this to mind is that I've been reading a fascinating book written by the photographer Margaret Bourke-White. She spent the and went back to do some photography. While she and her husband, the writer Erskine Caldwell, were in Moscow, the Germans attacked Russia. She had an opportunity to photograph the war firsthand in the its earliest days.

In her book, written and published in 1942 after she got back from Russia, she described her trip. In particular, I was fascinated by the inventory of things that she took with her. It included five cameras—custom-made Speed Graphic chimney cameras—all of her film, and all of her developing chemistry. She could develop her film on the spot, which she did in the bathtub of the hotel she was staying in, right there on Red Square across from the Kremlin in downtown Moscow. I supposed she did so to make sure that it was all done right.

One of the interesting stories she relates is that when she was entering Russia from China, the Russian border police used chopsticks to poke around in her cans of sodium thiosulfate—the fixer she was using—to make sure that she didn't have any hidden contraband stuffed down in her hypo-crystals.

She had 600 pounds of equipment she took in order to be able to photograph for just a few months. That included all kinds of equipment, not only cameras, but flash equipment, lighting equipment, darkroom chemistry, developing equipment, etc. It was quite an undertaking. And, of course, the funny part was that her husband the writer took one used, portable typewriter.

Aren't we glad that things have gotten a little easier for us here in the beginning days of the 21st century?!

## *Begin the Beguining*

I love big band music—Artie Shaw, Charlie Barnett, Glenn

Miller, Benny Goodman, and the gang. They're among my favorite artists of all times.

One of the things I'm fascinated with about the big-band era is how there was not an exclusive claim to any given song. It was not uncommon for all the big bands of the day to have a rendition of a great song. Artie Shaw's version of *Begin the Beguine* was the best (and best known), but almost every other band did a version of *Begin the Beguine*, too. It's just what was done back then.

I find this aspect of competing creatively a very interesting—and strangely healthy—form of artistic expression. The various bands fueled each others' creativity. There is a kind of excellence that was promoted and encouraged because it was open and direct competition.

It's interesting to compare that to photography today. Someone who goes to photograph the same image that someone else has already made is accused of being a copycat, and somehow their work is diminished somewhat as being not as creative as the original. The great virtue in photography today is to always be photographing something new and different that no one has ever photographed before. This is even more virtuous than photographing something someone else has done, but trying to do it better. I'm not sure that's always the best approach.

There's something healthy in what the big bands did that I think it'd be fun to re-create in photography. I'd like to conduct a little experiment, and any of you who would like to participate are welcome to join the fun. I've posted three images on our website, and I'd like to see what people can come up with as a rendition of these three images. You can download any or all three of them, and do what you will to them. I don't care. Have a ball in Photoshop. Make straight pictures; make exotic pictures; make combined recombinant images—I don't care. There are no rules, no restrictions. This is a creative experiment. When you've completed your creative work, e-mail it to me and we will assemble all the finished images into a PDF presentation on a future issue of *LensWork Extended*. [**This was published on *LensWork Extended* #64.**] That's the challenge! It'll be fascinating to see how many

different kinds of images and how many subtle differences there are, in the variations that result from different creative people working with the same image files. Good luck, and have fun!

# *Renditions*

Lately I have been reading a lot of W. Somerset Maugham. I really enjoy his short stories and the way he writes. He also wrote a number of short novels, one of which is called *The Razor's Edge*. It's a very powerful book. The reason I thought I'd mention it here in a podcast is because there are actually four versions of this great story that I recently ran across: the original book by Somerset Maugham; an audio recording of that book from Books on Tape; a 1946 movie version starring Tyrone Power; and a 1984 version starring, of all people, believe it or not, Bill Murray, in a very serious role done with a little sly comic light touch, the way only Bill Murray can do.

What fascinates me about this particular story is that in these four versions there are four really quite different experiences from the consumer's point of view. I think this has a parallel with photography. There are often a number of different renditions of a body of work, all slightly different and unique in their own regard. A good example is, about 20 or 30 years ago, I saw original 4x5 contact prints that Paul Strand had done of his work in the Hebrides Islands. I also own an original first printing of the book of that work, called *Tir a'Mhurain*. Recently *Aperture* published a new of version of that book, with better quality reproductions and higher quality scans. Here's an example of three renditions of essentially the same work.

What fascinates me is how different they are, and at the same time, how not necessarily better one is than the other. They have different qualities. In the Paul Strand original work, I think there is a magic to the original 4x5 prints that I saw, but at the same time, the first edition book has something magical of its own.

For sheer reproduction quality, the newer version that *Aperture* published is fantastic.

The reason I bring this up is because I don't think there's necessarily an argument to be made that one version is the best version of a print, or a movie, or a book publishing project. In fact, different renditions can have their own virtues, and that's a perfectly appropriate thing for us to remember as we're making photographs — that different renditions might be merely *different*, and not necessarily better or worse than others on all scales of measurement.

## *Anonymity*

If you really want to blow away your friends, then ask them the trivia question, "Who is Leo Gerstenzang?" That's right, Leo Gerstenzang.

This is a very important human being, for many of us anyway, and I'll bet you've never heard of him. If you have, you win the award for knowing the most trivia. Leo Gerstenzang is the guy who, in the 1920s, invented the Q-tip. I would be willing to bet that virtually everybody listening to this podcast knows what a Q-tip is. I'd also be willing to bet that very few, if any of you, have ever heard of Leo Gerstenzang.

My point is that what we *do* is often far more important than *who we are*.

This is not at all true when it comes to marketing in this day and age. Who someone *is*, is way more important, from the sales point of view, than what it is that they've produced, at least if we can give any credence to our public-relations firms, and to *People* magazine, etc. But I think from the artistic point of view, from the actual value in what we produce, what we produce is far more important than who we are. Hence, Leo Gerstenzang is not a particularly important individual, but his product is.

I think this is an important lesson for us to remember, at least for those of us who are trying to create things with our vision,

with our artistic efforts. What we produce is more important than who we are. Ultimately, when we are long forgotten, hopefully the artifacts that we've made will still be valuable enough and important enough that the people will see value in them. If that should be the case, I think we will have served the public well—even in our anonymity.

## *When the Art Demands Your Attention*

Most often, while I am sitting here working at my desk, I find myself listening to music. Typically during the middle of a workday, it's something in the way of classical music, or perhaps some light jazz—rarely something that's too hard rock, and rarely something that has words. I need to be able to concentrate on what I'm working on.

I had some Mozart playing in the background yesterday, and suddenly one passage of the music somehow, for some reason, broke through my concentration as I was sitting there working on some other stuff. I heard this piece of music and stopped. I replayed the music. I shut my eyes and just listened. It was so marvelous, so wonderful, it literally brought me to tears. This experience got me thinking how different it is to actually *listen* to music, as opposed to have it just playing in the background.

I feel exactly the same way about photographs. I know I have two completely different ways of looking at photographs. There are those photographs that hang on my walls and provide background for my environment. They're there, and I see them. There's no question that they're a part of my consciousness. But that's not the same thing as when I turn my total focus and attention to a photograph, or a book of photographs, or even an issue of *LensWork*. I often have an experience with *LensWork* when I pick up an issue that we published six months or a year ago. For some reason, I'll stop and look at the images—looking at them, really focusing on them and letting them play with my eyes, letting that light come in. Letting my consciousness

be totally focused on the images at hand is such a different experience from just having the pictures hanging on the wall in the background, or as a screen saver, or something on my computer. Minor White used to talk about looking at a photograph intently for 30 minutes, without commenting on it, with no words. Essentially, I think he was onto the same idea—that when you really look or really listen to a piece of music, it gets "in" in a way that's different. I find that the best photographs and the best music demand this of me—and I'm happy to comply.

## *The Danger of Slipping Standards*

We live in the age of do-it-yourself. I'm glad we do, because I like doing things myself. There's a lot of stuff that I do that, I suppose, previous generations used to farm out to professionals, or guild members, and I don't have to do that. I can do it myself.

But there is a consequence to all of that self-sufficiency that's worth being aware of, particularly as artists who are trying to create expressions that, I suppose, can compete with the standards of those people who created before us. Because we can create things ourselves, there is a natural slippery-slope tendency for standards to drop. This really became apparent when desktop publishing got to be so popular in the late 1980s, and through the 1990s. All the people who were design and layout and topography experts, who had been trained in it and knew all about layout and design, cringed whenever they saw the product of some amateur attempting to do a layout, or design a newsletter or some book publication. These amateurs suddenly had desktop publishing and the ability to use bizarre fonts. We still see that, from time to time. I still see websites, or PDF files, or book publications, that are obviously done by amateurs.

The precaution here, of course, is that, yes, we can do it ourselves, but we should be very, very clear about the standards of those who worked before us, and what they discovered, invented, and created with the excellence of their abilities, and in

spite of the primitiveness of their tools. Our tools are so much easier, so much faster, and so much better, but our eye, our sensitivity, our creative minds, need to be just a sharp as theirs were, even though our mechanical skills maybe can take advantage of the newer tools. When you are creating something with new tools, be aware of the excellence of those who have gone before you. Make sure that whatever you are creating is up to their standards. After all, if they could create to those standards with such primitive tools, we should, at the very least, do as well as they did, and probably excel. There is no excuse for us today, with our tools, to create something that does not measure up to the standards of those who went before us with so much more primitive tools at their disposal. Just because it's easier today is not an excuse for us to be sloppier.

## *When Does Art Begin?*

Years ago, I had a very good friend who was a photo buddy, and we spent a lot of time photographing together and shooting the photographic breeze. He's a terrific photographer, and really a master printer. He's been to the Oliver Gagliani two-week workshop on the Zone System. He built an absolutely gorgeous darkroom. He had perfected his craft, really, and gotten to the point where he could make a terrific print. He was as good a printer as I've ever known. But, after he had spent all that time and energy developing that skill, he gave up photography. He just stopped doing it. Sold all of his equipment, shut down the darkroom, took up golf.

His abandonment of photography bothered me for a long time. I realize this is not uncommon. A lot of people go through this. His was just the first experience like that I'd seen close at hand, firsthand from a friend. I've talked to some of these people over the years who have walked away from photography and I've seen essentially the same pattern: the craft of photography, the process of making a great black-and-white photograph, was so

intriguing, so spellbinding, so mesmerizing, that these individuals got caught up in that. They found the pull of photography to be absolutely magnetic. They dedicated a significant portion of their life to photography. They committed to it. But once they had developed the skill to execute their craft cleanly and consistently, and they could make great prints, they discovered that was when the hard part of photography begins. Then is when you have to become an *artist*, not just a craftsman.

A lot of these people find that they don't have anything to say. They wouldn't come right out and put it that way—what they say more typically is, "I don't know what to photograph." I've always felt that when you get to the point where you say, "I don't know what to photograph," that's when you actually begin the process of being an artist. Rather than get frustrated and quit, it seems to me that then is when photography really ought to be getting exciting. It's no longer just photography. It's no longer just printmaking. It's artmaking.

I've always felt it is sort of sad that people get frustrated because they don't know what to photograph once they've mastered the craft , particularly if that becomes the motivation for them to drop out of photography. Really, that's the opportunity to engage artmaking at a significantly more meaningful level, when it's no longer merely making technically competent images, but starts exploring the human condition, and the soul of the artist.

## *Nine Pounds*

I'm getting ready for a photography trip to Wyoming and preparing some new equipment. In this particular trip, I am going to be experimenting with a digital camera, so that's the main camera I'm going to take. Since I'm sort of new at this digital stuff, with the new equipment I've been spending some time getting familiar with it, packing it and, quite honestly, figuring out what I'm going to take.

I put together my new field pack for this trip. It consists of

a Sony digital camera with 11 hours' worth of battery life. I have enough flash memory for about 360 full-resolution raw exposures, a lens hood, a circular polarizer, a neutral density filter, a cable release, an OptiVisor—so I could see the doggone screen. I had some room left over, so I put in a digital stereo recorder, a stereo microphone, stereo headphones, and enough batteries and flash memory for about 40 hours of digital recording in the field.

Of course, I've got a lens cleaning kit, an emergency mirror, a flashlight, a walkie-talkie, some first-aid items, a jacket, a pair of gloves, sunglasses, an MP3 player, and binoculars. Including my Lowepro Sling Bag holding all of this stuff, the bag and all its contents weighed 9 pounds. Add to that the carbon fiber tripod with the geared head that I'm using, the total package only weighs 14½ pounds!

Back in 1990 during my trip to Japan, I carried 8 pounds worth of film holders and film! The Cullman tripod and Bogen head I used in Japan weighed 13 pounds all by itself. Either I was stupid back then, or at least when it comes to the considerations of weight and our poor, aging backs, technology is our friend.

Of course, it remains to be seen whether or not all of this new lightweight equipment will perform up to the same standards as my pre-World War II Arca Swiss monorail. But, from the simple perspective of carting all this stuff around so I can have it when I need it, I must admit, I'm glad I live in the generation that doesn't have to haul with me glass plates and portable darkrooms—or reel-to-reel tape recorders—when I head out into the field.

## *Great Photographers Can Succeed Even When the Printing Does Not*

In the little town of Anacortes, Washington where I live, we have a brand new library. It's less than a year and a half old, a beautiful new building with lots of room to grow. It's a spectacular structure. Upstairs in the back corner, near in

the fireplace (which is a lovely room), I was surprised to find a complete collection of *Life* magazine going back to the very early days. They are all tucked away in binders—obviously someone had collected these things and bound them for library use. Maybe it was a donation, I don't know, but there they are.

Obviously, these old issues of *Life* magazine contain the great photojournalistic essays by Eugene Smith and all of the other photographers who made such wonderful contributions to *Life* over the years. I've taken to looking through these to see what these things look like. I ran across a Eugene Smith essay that was absolutely spectacular. It's the one of a country doctor. They have it right there, in our library. It's really a marvelous thing to see.

But what really impressed me when I looked at this old *Life* magazine was how absolutely horrible the reproductions of these photographs were. But it didn't make any difference! Seen in the context of those magazines, the power of those photographs to communicate came through in spite of really bad printing technology. Great photographs—really *great* photographs—can succeed in spite of questionable reproduction. I think that's always been the case.

I'm very proud of the reproductions that we do in *LensWork*, and the printing is really terrific, but I know that a hundred years from now—50 years from now, 20 years from now, maybe 10  years from now—printing presses will be even better than they are today. People will look back at *LensWork* and say how primitive its printing was, and comment how it's not up to the standards of the contemporary printers of those days, a hundred years from now. My hope is that the images in *LensWork*—and the images that we make today in our generation—stand up in spite of today's relatively primitive printing technologies, at least in comparison to those future printing technologies. Here at *LensWork* we try to focus on what counts in photography, which is the power of the photograph, the impact of the content, the connection, the message, the spirit, not just the way the dots are printed on the paper.

# Moving Backwards with Technology to That Wonderful Black and White

More than a few people have theorized that had color photography been invented before black-and-white photography, perhaps black-and-white photography would never have been invented.

Instead, as it turns out, the chemistry and whatnot that was required to make black-and-white photography was easier than color. Therefore, black-and-white came first. As a result, we have a black-and-white aesthetic now. A lot of us love black-and-white photographs.

One of the interesting things about that is in this latest iteration of technology, the digital camera, all the pictures are made in color, whether you want to or not. I know on some cameras you can set it to do black and white, but essentially you are recording RGB — red, green, blue — or some variation thereof in the photographic sensor. There is no such thing as a black-and-white sensor in today's cameras. So we're in that situation where in order to be a black-and-white photographer, we have to modify what the equipment is intending to do because the equipment wants to make color photographs! When we make the choice to do black and white, we choose to go backwards in technology in order to create the artistic vision that we see — back to that wonderful black and white that we all love.

# Why I Record Field Audio When I'm Out Photographing

A podcast listener asked me about my 9-pound field pack that I was discussing the other day. He asked why I chose to take a stereo recorder and microphone with me into the field. I think this is a more interesting question than maybe he thought he was asking.

I've become more and more enamored of late with the idea

of digital publishing and PDFs. Multimedia presentations with photographs can engage people's auditory senses, and the more we can get contact with them the more we connect with them. That's why movies and television are so powerful. They stimulate not only the visual senses, but also the aural senses with the spoken word and music. If we could have even more senses involved—like they do at Disneyland when you do the theme park rides and the seats move, and they spritz you with things that smell—the more we can get our senses involved in communicating something, the more powerful that communication may be.

Well, I'm primarily a photographer. I love the visual sense that photography has and the unique way in which photography presents a visual presentation. But I'm also fascinated at how still photographs (I'm not particularly captivated by the idea of making videos, even though I've made a few) can be married with sound. To me, it's a very intriguing idea. So that's one reason I take a recorder with me into the field—to record sounds of what it is that I'm photographing.

I'm also very interested in photographing people. In the portraits I've done the past, I found that recording people, even just in casual conversation as I photograph them, gives me insight to their personalities, their concerns, their lives. I find those recordings can be very helpful in my thinking through what it is that I'm trying to do in a portrait as I'm making it, or what it is that I'm trying to do with a portrait while I'm printing it.

I learned this primarily with my *Made of Steel* project in the early 1990s. I captured the anecdotes and stories of these old guys that work in the machine shops. I wish now I'd had a good quality recorder so I could use that audio in multimedia. Instead, all I had was just a cheap little microcassette tape recorder. I thought all I was doing was capturing their words for transcription. I wish now I had understood the importance of capturing that audio for use in multimedia.

I suspect that as time moves on and technologies continue

to integrate, more and more of us traditional black-and-white still photographers are going to use some form of multimedia, DVD presentation, PDF file—who knows what. I can't begin to predict what the future media might look like—but I would be willing to bet that we'll be glad that we have audio components for some use that we can't predict. That's why I take the audio recording equipment with me in the field and use it as often as I can, and with as much diligence and professionalism as I try to bring to my still photography.

## *Redefining the Term "Current Work"*

A couple of weeks ago on Sunday night, I got a phone call from a friend who said, "What are you doing today? Have you been out photographing?"

I said, "As a matter of fact, I have been."

He asked, "What are you working on?"

I replied:

"Well, interestingly, I went out this morning with my new Sony digital camera, just to play around with it a little bit, to see what it could do. The weather was rainy, drippy, and cold. I did a couple of exposures and decided I didn't want to spend any more time out there in the yucky weather, so I came back.

"In the course of thinking about what I'd done during those couple of exposures, it reminded me of an image that I had made years ago, a negative that had been destroyed. I'd never been able to make a decent print of it. *That* got me to thinking about some older negatives I have that go way back that, similarly, I've never been able to make a print like I would like to make. I decided that when I got back home, I'd play around with one of those.

"Anyway, after I got back home, I worked on the digital image that I had just made that morning and made what I think is a really terrific print. It's a sweet little picture in the woods, and I really like the image.

"Then I started rummaging around through some of my older

negatives and I found one from 1983 that I'd always wanted to print. I'd set it out on the enlarger table, ready to go the next morning when I was to wake up and go to work in the darkroom, back then in 1983. It just wasn't destined to be. During the night my cat got a hold of the negative and chewed it, scratched it, and I've never even tried to make a print. Interestingly enough, I also didn't throw away the negative. It's been sitting in my archive folders all this time. I thought, hmmm, maybe I could scan it, do a little repair work now in Photoshop and make a print.

"So, I did so. It happens to be a sunken boat in the misty fog, a very high key light and delicate print."

My friend, hearing the stories about what I'd been working on, said, "Seems to me like you've redefined the term *current work*."

How odd it was that the two images I was working on a couple of Sundays ago, were one I had made in the morning—that morning—and one I had made some 23 years earlier—and both of them I could define today as "current work." It was an odd concept to come face-to-face with, but I had to admit that thinking of the term "current work" in terms of the *prints* that I'm making today, rather than the images that I'm *photographing* today, made so much sense. So, I'm prepared to say that my current work spans 23 years. How odd.

## *The Date of a Print*

In my last podcast, I was discussing the idea of the term *current work*. That gives me pause to think about how we *date* our work.

I've discussed this with a lot of photographers over the years, and most photographers, I think, tend to date their work based on the time they made the negative or the exposure. That makes perfect sense. But the other way to look at this is that the work—that is to say, the *finished* artwork—is not the negative, it's the print. Of course, as we all know, if you make a print today from a given negative, and you make a print tomorrow, or

next week, or 20 years from now, that print is likely to be considerably different than the one you make today. So there is a date for the negative and there is a date for the print. The question is, *what is the date for the work?*

My idea on this has always been to use both dates. That is to say, on every print that I make, I specify the date of the exposure, and that becomes the date that I use in the title of the print. But, I also include the date that I made the print, usually in the colophon, or in the case of an individual print, in the provenance area. I date when I make the print because I tend to think that, from an historic point of view—and I flatter myself with this, I must admit—if anybody, someday in history, should be interested in knowing the history of that particular print, both of those dates will be critically important. The date I made the exposure is the determining factor about what was captured on film. But the date I made the print says a great deal about my personal history and my personal vision relative to this image, relative to photography—and even relative to the materials that were available at the time.

When I think in terms of the *full* provenance of an image, both dates are critically important. But that's not the end of the story. Now, in the world of digital images, there can be a difference between the date that I do the creative work on the digital file, and the date that the print is made—which can be a different thing than the original prints because papers may have changed, inks may have changed, or I may use a different printer. Now there's a third date that I include in the provenance: the date I do the creative work on the digital file.

One final comment, that's related to all this business about print dates. What is the date that we use for the copyright? I'm not a lawyer, so please don't take my advice as legal advice, but I always use the date I make the *print* as the copyright date. As I make additional prints over the years, the copyright date changes to whenever I made that particular print.

So what's the date of a print? Well, in my way of thinking, that's a more complicated question than you can answer with

a single date, so I include them all: the exposure date, the creative work date, the print date, and the copyright date. There's a purpose and a reason to use all of these in the provenance of a print.

# *Why I Became Interested in Photography*

There are probably about as many reasons to be involved in photography as there are photographers who are involved in it. In my way of thinking, they're all pretty valid reasons.

Some people want to be involved in commercial photography because they want to make money. Some people are involved in fine art photography because, well, some of them want to make money, and that's okay. Some people are involved in fine art photography because they're interested in museums and having their work in important and historically significant collections. Some people are involved in photography because they're interested in motivating and manifesting some kind of social change, and that's great, too. That's one of the great things about photography: it's malleable and can be used in lots of different ways for the objective that each photographer brings to photography.

My objective is perfectly sensible to me. I got involved in photography because I want to share my creative vision with people. I want to make photographs that people can enjoy. So, I've chosen a method of making photographs that's consistent with that. And I've chosen a method of pricing photographs that's consistent with that, and I want to share with you a little story now that illustrates this, I think, better than anything else I could possibly imagine.

I'd like to talk about something that I'm afraid will run the risk of sounding somewhat self-promotional, and that is not at all what I'm trying to do here. Please excuse that and try to listen carefully to the message. Sometimes when I talk about these things, it's best if I use first-person experiential examples, and in this particular case I'm going to do that, fully cognizant

of the fact that it may run the risk of sounding a bit self-promotional. But anyway, here we go.

I've had, recently, a very interesting experience relative to photography, and it all started on April 1st, when I went out with my new camera and photographed an image I now call *Fallen Log, Rain, Mt. Erie.* I then did a podcast about it because I had photographed that print first thing in the morning on Sunday, spent the afternoon working on the image in Photoshop and printing it, did a podcast of that experience the following Friday, on April 7, and mentioned in that podcast the experience of photographing this print. I'd also taken that print and posted it on my personal website as one of my pigment-on-paper (some people call it inkjet) prints for $20. We sold quite a number of them that weekend. That obviously wasn't the objective of the podcast, but it was a consequence of the podcast. I was grateful for all the people who were motivated enough to purchase the print.

Well, I received the following e-mail on April 19, literally less than three weeks from the day I exposed the original print out in the woods. In the course of three weeks, I made the print, printed the print, talked about the print, sold the print, shipped the print, and received the following e-mail about the print. It's from a person who purchased the print; his name is John. John wrote, "The other day I made my first order of another photographer's print. I saw your image *Fallen Log, Rain, Mt. Erie,* and it moved me to order it. I anxiously awaited its arrival, which happened today. It's great! I will frame it and display it proudly. Thank you for the professional way it was shipped and the added valuable information you included with it...", etc. He goes on to talk about some other issues, but basically it was a fan letter, an appreciation letter, and I thought, you know, that's great! How wonderful! I really appreciated receiving his e-mail.

The following day I received this e-mail from a person named Dwight, who wrote, "Hi Brooks, I've received your *Fallen Log* print and I just wanted to write and let you know how much I like the print. Thank you for making this available at such an affordable price. I'm a dentist for low-income children and families. I find it

to be the most enjoyable way to earn a living, but I don't have any money to spend on expensive art or other luxury items. I'm grateful that you've made this available at a price anyone can afford."

The reason I mention these two e-mails is, again, not at all for self-promotion. (I'm a little embarrassed to use these two, but it's such a great example that I can't resist it.) This is precisely the reason I got involved in photography. I wanted to be able to share my creativity, my unique vision of the world, my artistic efforts with people. That's why I became a photographer, so I could do this.

Partly, this is a comment about why I got involved in photography; partly, this is a comment about technology; partly, this is a comment about pricing. I know that a lot of this flies in the face of the traditional way that photography has been produced and manufactured. But you know, for me, the bottom line is, the reason I got involved in photography was to share my creative vision with other people, and here I am sharing my creative vision and having them tell me how much they appreciate it. I'm sharing my creative vision in a way that makes it *possible* for them to appreciate it. How can you feel any other response to this kind of scenario than extreme gratitude?

So, for those of you involved in photography because you share a similar objective—you want to share your creative vision with people, and the sharing part is more important than the technological part, or more important than the commerce part—I thought you might find this story, maybe, inspirational, I guess.

Thanks to all of you out there who have found these prints enjoyable. Thanks for letting me know that you found these prints enjoyable, and thanks for giving me, essentially, additional motivation to keep working.

## *Those Marvelous Contact Prints*

Last week, I had an opportunity to look at some contact prints

which I haven't looked at for quite a while. Most work that we receive here at *LensWork* now, for submissions, is usually enlargements, or sometimes digital prints on occasion, but contact prints are sort of a rarity.

It was such a joy to look at these contact prints! These were all 4x5s and they were absolutely spectacular. It's not like I'd forgotten how gorgeous contact prints can be, but sometimes when you haven't seen something for a while and then see it again, you're reminded what magic it is.

For those of you who do enlargements or digital prints, those are fine technologies, too. But I have to admit, contact prints from black-and-white film are the technology that has always made my heart go pitter-patter the most. I've felt this way ever since I first saw contact prints that Edward Weston did from 8x10 film. I was just blown away by the smoothness of those tones and the incredible detail that gives you this feeling you could just sink into the print. Once again, last week I was reminded of that, and found myself digging out some of my old books to look at those photographers who specialized in making contact prints.

If you're lucky enough to own that old Friends of Photography *Contact Print* edition, dig it out again, and take a look at it. There are some absolutely marvelous photographs in that book.

## *The Courage of Your Convictions*

There are many, many skills a photographer has to have in order to be successful at creating any kind of a personal vision, something that is a personally expressive creative photograph. But as I've gotten older, I've begun to realize that probably the most important characteristic a photographer needs to have is the *courage of their convictions.*

There are a thousand and one people in art, in life, in photography, who will try to tell you what to do, how to do it, how it ought to be done, what looks right. This will cover every single

topic from composition to subject matter to presentation. The one thing that is absolutely crucial for an artist to be is *independent.* Be true to yourself, and think and know what it is that comes from within you. Have the ability to separate that from what is being thrown at you from the outside world in an attempt to influence you, or corral you, or make you think, or act, or produce, or create, in a certain way.

That's not to say that there aren't places where societal roles and feedback can't be important—there are. Knowing how your work is seen by other people, knowing how it fits in the context of society at large is important.

But when it comes to one's motivations, one's true voice, one has to develop the ability to be a bit thick-skinned, I guess, and to listen to your own internal creative muse. Then damn the torpedoes, full speed ahead, and don't let the people who try to tell you how to make photographs—don't let those people get in the way of you discovering how you need to make your own images.

## *I Don't Like It—Okay, but Why?*

I think one of the very best things the Internet does is that it gives us a sense of community that's a lot broader and farther reaching than just the people who live near us geographically.

I follow a number of the chat rooms, bulletin boards, and those kinds of groups that are photographically oriented. I like to see what people are talking about, what they're interested in, etc. One of the very consistent themes that comes up in almost every bulletin board or photography community is the occasional question, "What's your favorite magazine?" Well, obviously, as a publisher of magazines, this one always piques my curiosity. I'm always interested to see what people like and don't like, and what they prefer and what they don't prefer.

One of the interesting things I've noticed in such discussions, for years now, is how many people judge a magazine by how

much it promotes the kind of photography that they do. As consumers, of course, we're most likely to be attracted to things that we like, and that's perfectly natural. But, as artists, I think it's sometimes very important for us to take a look at things that for us as artists, the response "I like it", or "I don't like it", is not a very productive response. Instead, there's a great deal to be gained by trying to think about *why* you like it, or don't like it, and go beyond the mere reflexive response.

Obviously, if the only images we ever look at are the ones that we really like, and those are most often the ones that are somewhat similar to the kinds of photography that we do, we'll find ourselves sort of in a little box, without having much expansiveness to our horizons. That's why I think it's a great idea for photographers to consider not just photography publications, magazines, books, and websites, but also to go look at what's happening in the other arts. Pay attention to music. Pay attention to painting. Pay attention to literature, to poetry, to lots of different kinds of ways in which people are being creative, how they're using their skills.

One of my favorites watching the cooking channel. I probably learn as much about photography and creativity by watching the Food Network as I do from photography-related websites.

When you find something that you don't particularly like, I might suggest that there is value in trying to think about *why* it is that you don't like it, not just turning it off, or flipping the page, or moving on to the next website, or the next magazine, because you don't like it. But ask yourself why, and try to think through what it is about what's being presented to you that doesn't work. There's more to be learned by looking at what doesn't work in those situations than to simply close the page, move on, and discount it as something that's not worth your time. In fact, it may be very much worth your time, if you can learn something from it that helps you think more clearly about your own creative work. That, in itself, can be a heck of a contribution from a publication—or a website.

# An Example of Why the Public Thinks Artists Are Buffoons

I've mentioned in a couple of articles and podcasts that I think the rest of the world tends to look at artists as goofy people, as abnormal. Somehow there's something wrong with artists.

Being an artist myself, I've found that a bothersome observation. I don't like being categorized as weird, or abnormal, or somehow out of touch with mainstream values and the mainstream of society. I'd like to think that art has a place in mainstream society and should be perfectly in contact with the everyday life of everyday people. On the occasions when I've made the observation that the general public thinks artists telling me how ridiculous I am, and how the public *doesn't* think they're goofballs. Well, here is a case in point. I really hesitate to mention it because I don't necessarily want to give this person any additional publicity, but it makes my point so well I can't help it.

There is a woman named Ellen Jong who is a photographer. She has a brand new book out called *Pees on Earth*—that's right, *pees*, as in urinate. Here is how this book is described on the Amazon.com website. This is a quote from Publishers Weekly:

"A photographer and multimedia artist whose work has appeared in *Vogue* and *Playgirl*, Jong likes to pee in public places. At first glance, this book of photos, documenting her urinary exploits, seems like a one-trick pony, but Jong's humor, charm, and sense of beauty cumulatively create a rich experience. Grungy urban locales alternately elicit disgust, giggles, and titillation. A stream of golden drops pouring into gravel by a reedy pond is lyrically gorgeous. Jong relieves herself in New York City, Hawaii, Shanghai, Mexico, Florida, in the city, suburbia, on the beach, and doglike into snow. The captionless photos are interrupted by Jong's interview of ex-prostitute/sex maven/ performance artist Annie Sprinkle, whose name may be inspired by her own public peeing performances, and who categorizes

Jong's work as 'post-porn:' 'sex- or body-oriented material, that goes beyond mainstream porn or erotica.' In fact, these photos are more likely to be funny, pretty, or childishly mischievous than erotic. Jong writes of peeing as a 'means to reevaluate the spaces I find myself in to make them my own,' and the peace in release. Balancing precariously between aesthetic inspiration, hip party prank, and self-indulgence performance art, this book is apt to annoy those who aren't enchanted by it."

Well, that's what Publishers Weekly had to say. I am amongst those who consider myself annoyed by it, because I think this kind of junk insults all of us who are trying to be, or are, serious artists. This is a publicity stunt. I don't think this has anything to do with art. And to make my point about how goofy the public thinks artists are, I dare you to show this book (or show this para-graph) to your grandmother, or even your parents — to everyday ordinary people on the street — and ask them what they think of the concept of this book. I suspect I'm not unique in the fact that my parents, and my grandparents, and my elders and betters, as they're called, taught me not to pee in public, and certainly not to pretend like it's artwork! Most of us — most of us *civilized* people — would consider such behavior abhorrent. It's not just antisocial, but tacky, primitive, uncultured, crude, insulting, and thoroughly inappropriate, at least for civilized people.

It may not be perfectly fair for me to single out one book as somehow indicative or representative of the world of art, but it is in the world of art. It is a photography art book, and it's going to be seen in the photography art book section, along with all the wonderful art books that are made by people who really are creative people, and who don't need the term "urinary exploits" to describe their artwork. *A stream of golden drops pouring into gravel by a reedy pond* is not, and cannot be, "lyrically gorgeous." It's pee.

I don't think this woman should be censored. I'll defend her rights to free speech with my last breath, as they say, but there's a difference between censorship and good taste. In my opinion, this project, this book, this so-called artwork, goes so far beyond

good taste as to be just ridiculous and an insult to the terms "art" and "art photography." Needless to say, even though I think she should certainly have the right to do the work and to publish the book, she's not going to get my hard-earned money, and I don't hesitate, and don't mind, offering her my criticism, my derision, and my laughter at her stupidity. This is just silly.

## *The Courage of Your Buffoony Convictions*

There is age-old wisdom that advises us to "look before we leap." But, of course, there's also wisdom that tells us that "he who hesitates is lost."

There is wisdom that tells us "many hands lighten the load," which of course, seems to be contradicted by the idea that "too many cooks spoil the soup."

Life is full of such contradictions. And, for those of you who follow these podcasts, it appears as though I may have proposed a couple of contradictions this week when I advised people to follow their heart and create the images that come from their inner soul—to have the courage of their convictions, in short—and then, a couple days later, I chastised a woman for doing exactly that and producing a body of work and a book that I thought was just ridiculous, and horrible. I was quite hard on her in my criticisms.

How do I reconcile these differences? Well, quite simply, I think that as artists, we have to recognize that there's a difference between ideas. There is freedom of speech—our ability to say what it is that we want to say. This does not at all imply that we also have the right to have what we want to say *heard*.

The audience—people who look at our artwork—have the same rights that we have. They have the right to *reject* our artwork—to say that what we've done is silly, and foolish, and ridiculous. It's simply not, in my way of thinking, a contradiction to say that we should have the courage of our convictions, to say what we want to say, and at the same time recognize that

this puts us in a position of vulnerability. People may not like what we've said. Or they may reject what we've said, or how we've communicated.

There are photographers who are very lucky in that what they create from their inner soul, from their creative muse, is *exactly* what the audience loves, wants to pay for, and love them. And then there are other artists, other photographers, whose work is not in sync with the audience—at least not the audience of their day. It may be that their work will be admired, and appreciated, and collected long after they're gone—50, 100, or 200 years from now. That shouldn't, at least in my opinion, influence what it is that you choose to do today.

Although the audience may be important to us from an encouragement and a motivational point of view, it isn't fundamentally important to what it is that drives our work. It is, on the other hand, a reality that our work will be seen by an audience and runs the risk of being rejected. That's why to be an artist takes a certain amount of courage, a certain amount of thick skin, a certain amount of fortitude, and a strange combination of the courage of our convictions that gives us thick skin and the humility required to know that our work is ultimately going to be judged by an audience who may, or may not, agree with our vision.

## *What Inspires You?*

Let me ask you a deceptively simple question: Where does your inspiration come from? I don't mean that as a rhetorical question, I mean it as a practical one.

Maybe I should rephrase the question and say, "Where *has* your inspiration come from?" Look back on all the best work that you've done in your photographic career, or as far as that goes, in other aspects of your life. Ask yourself that practical question. What inspired you to do your best work?

Is it possible that understanding the inspiration for our best

work is a clue to finding the inspiration for future work? I think every one of us is likely to have a somewhat different answer to this business about inspiration. I know for me, mine always seems to come from excellence. Whenever I find myself reading a really terrific book, or viewing some wonderful artwork or photography, or listening to extraordinarily good music of any kind—it doesn't make any difference what field the excellence is in—when I see excellence, I'm inspired to do more excellent work. It motivates me to me to raise my own personal standards, and to try for something that's better than what I've done before, to reach for the heights of excellence that I've seen that others have attained. Not that I'm going to copy them, but rather that I'm going to springboard off of their excellence toward my own motivation.

When, on the other hand, I find myself reading junk, or watching bad TV, or a crappy movie, I find myself getting depressed and I don't want to do any work at all. Knowing this about myself, I find I can actually generate inspiration by paying attention to what I'm surrounding myself with. By specifically and purposely surrounding myself with excellence—excellent music, excellent books, etc. – being involved with excellence makes me want to be better myself. That's what works for me. What works for you may be entirely different.

What I'm suggesting is that whatever it is that inspires you to create your best work—to understand that and to pursue that specifically is a virtue, in and of itself. It may be just as good as going out looking for something to photograph, or looking for motivation in terms of what you want to photograph. Find out what other kinds of things inspire you and motivate you first, and then use that inspiration, turned to the direction of your artwork.

# *Do You Find Photography to be Fun or Serious or Both?*

The other day I was reading an essay by Robert Hutchins, one of the editors-in-chief of the Britannica set called *The Great Books of the Western World*. In his essay, he was lamenting how we don't spend as much time reading in today's society as we used to—obviously, he was advocating reading his particular set of books. I ran across a quote that I thought was absolutely fascinating, particularly when I applied it to the pursuit of fine art photography. He wrote:

"Now we have the Fun Society, molded and supported by Technology, Affluence, and Advertising. The question now is not *Are you doing anything worthwhile, anything interesting, or important?* The question is, *Are you having any fun?* With all the gadgets, the aim of which is to provide comfort or amusement, and all the affluence that has made it possible to buy them, and all the advertising the urges us to do so, fun has become something bought with money, supplied by gadgets, and endorsed by advertising. If we aren't doing something that involves these elements and meets these requirements, we can't be having any fun."

Then he goes on to advocate the idea that reading can be a fun activity. I thought it was fascinating how he opposed the ideas of "doing anything worthwhile, interesting, or important" against the idea of "having fun." True, in his case talking about reading, in my case talking about fine art photography, it is very possible—it is very likely—that doing something worthwhile, interesting, or important can, in fact, be fun. So the point of his essay was to promote the idea that having fun and doing something worthwhile and important are not mutually exclusive.

I thought his point was perfectly applicable to fine art photography. In fact, we can do something worthwhile, interesting, and important, and at the same time have fun. But we have to unlink in our thinking—and in our practical ways of doing things—we have to unlink the idea that fun is something

supported and molded by technology, affluence, and advertising. Said another way, I've written for years that photography is not about equipment. It's about seeing; it's about creating; it's about producing something from your inner soul. We do, undoubtedly, live in the age of Nintendo and 256 channels of cable TV—distraction, diversion, fun, and entertainment. But fundamentally, I still cling to the idea that fine art photography is not distraction, but is something much more meaningful than that. That it is, in fact, a slightly higher pursuit. But, in using the term *higher*, I don't mean snooty. It's not lofty, it's not boringly educated.

If we choose to approach it as a distraction, a diversion, an entertainment, what we are likely to produce is probably not going to be very worthwhile, very interesting, or very important. There is a certain seriousness about the pursuit of fine art photography that is important—or maybe it would be better if I would use the words *there is a certain sincerity*—that has to accompany our pursuit of fine art photography—not that it has to be serious, and grave, and dour. It can be fun, but it does have to be something that we pursue with a certain amount of dedication, that leads us to think of it as something that is not trivial. The challenge is to find that very delicate balance between being stuffy, on one hand, and merely trite or clever, on the other.

## *Thoughts on Technology and Its Influence on Aesthetics*

I'm fascinated with how technology influences aesthetics to a certain degree.

I first became critically aware of this a number of years ago when we did a *LensWork Special Edition* print by that great photographer Jay Dusard. He'd done a landscape with a panoramic camera that he'd made. This particular camera, and the lens that he used to make this picture, caused some serious vignetting in the upper left and upper right corners of the image. The lens

didn't have a large enough image circle to completely cover the film. He struggled with this over a long time, trying to flash it, dodge it, burn it, using various darkroom techniques, and he never could get it to work. Finally he decided, after looking at some older pictures from the 19th century, that often they simply rounded corners of the image to get rid of the vignetting! He thought that was a fine idea. So he did that, and it worked extremely well in that particular image.

That got me to thinking about the works of Eugene Atgét and how his cameras used glass plates. In most of his pictures you can still see the little pin holders that held the glass plates in place. Almost all of his photographs are perfectly people-less streets in Paris, not because there were no people in the streets of Paris, but rather because the time exposures that were required for him to use with those glass plates were so long that the people literally disappeared in their movement. The only thing that can be seen in so many of his photographs are just the still buildings, the trees, the streets, etc.

The reason I bring this up is because I think there's an interesting question to be asked about how the technology that we're using today is influencing our aesthetic today. For example, what is going to be the aesthetic impact of Photoshop on digital images? I think it's clear it's not going to be simple recombinants like Jerry Uelsmann has done, but is likely to be something else that's going to come out of Photoshop, just like there has been from every other previous technology. When it does, my suspicion is that it will tend to date these photographs, just the same way that vignetted corners tend to date landscape photography, or the glass-plate pins that Eugene Atgét has in his photographs tend to date his images. There will be something that Photoshop does, aesthetically, that will tend to date those images as being about now, in our time. It was popular for a while in the 1960s to include the sprockets of 35mm film in the final image, or the cut edges of the 4x5 sheet film in the final image. There will be something that evolves in Photoshop that will tend to date those pictures as a Photoshop creation.

Of course, that won't be the last time that technology influences aesthetics. I have great faith that Photoshop is just one more iteration of photographic technology in a long history of change. Who knows what will be used to produce images 50, or 100, or 200 years from now? There will be something. But whatever it is, there is always an impact that the technology has on the aesthetic.

As photographers, I think it's a fascinating thing for us to not only be aware of, but perhaps to use, to exploit, to avoid — to at least *control*, with conscious control, when we are creating our work.

## *Ryan Scott Mach, Future Podcaster*

Well, it's been a while since my last podcast and I apologize for being gone for so long. I really appreciate all the e-mails and notes we've received from people wondering if we discontinued the podcast or where I've been. To know there are so many of you out there who value these podcasts is really very encouraging to me. So, for all of you who have written and e-mailed about me, thanks for all of your concern!

Quite honestly, the reason I've been gone for awhile is, I've just been swamped! The last couple of months have been mind bogglingly busy.

First, I had successful surgery to remove a melanoma — and everything is just fine there; then I was gone for a weekend to Sunriver with my family and my very pregnant daughter and her husband for our last get-together as just adults before the baby arrived; then we wrapped up *LensWork* #65 and sent it off to press; then there was a Father's Day weekend in Portland with my family; then Maureen and I headed off for a week in Monterey and Carmel interviewing and videotaping photographers for future issues of *LensWork*. On that trip both of us ended up getting a stomach flu. After we came back, Maureen had what we feared at the time might have been a heart attack and was rushed

to the hospital in an ambulance. It turns out she did *not* have a heart attack. She had some complications from that flu.

After that little episode was complete, we wrapped up *LensWork Extended* #65 and sent it off for duplication and—oh, yeah—my daughter had her baby about 10 days ago. Ryan Scott Mach was born on July 7—7 lbs. 1 oz., 20½ inches—our first grandchild.

I think it's only appropriate that he have an opportunity to participate in his first podcast: this after he was just a few hours old [sounds of baby Ryan crying]. Ah, the lungs of a future podcaster like his grandfather indeed. So, that's why been gone and I appreciate all of your patience and the podcasts are back on a regular schedule. I'm looking forward to getting back and talking about photography with tomorrow's podcast. See you then!

## *Workspace and Living Space*

I mentioned yesterday that Maureen and I recently visited several photographers in the Monterey and Carmel area preparing some interviews and videos for future issues of *LensWork*. One of the things that struck me when we were down there visiting each of these photographers is how their living space is almost entirely devoted to photography. One photographer I visited lives in a trailer that is, for all intents and purposes, a space entirely dedicated to photography—darkroom, office, print-mounting and matting area, print viewing, spotting, etc. Up in the front a is little tiny kitchen.

Another photographer has his entire house essentially dedicated to photography in the sense that his dining room, for example, doubles as his library. In every room in the house there are photographs to be seen, both his and lots of others that he has collected over the years. He has an office space that's totally devoted to the digital aspects of his photography. He has a full darkroom and matting area; he has a shop where he can do his

own custom wooden frames. His entire living space is dedicated to photography.

Those of you who've taken a workshop from John Sexton know the size of his studio and his darkroom and his working area that is the vast majority of his house. Very little of his house is left over for, as it were, "normal life."

Another photographer we met had a huge studio and work-space separate from his house, but even throughout his whole house there were giant photographs of his up on the walls as well as photographs by other photographers who inspire him.

In all of these cases, photography is not just a hobby, not just a compartmentalized section of these great photographers' lives, but rather it is an essentially all-consuming thing. They live, eat, and breathe photography; they look at photographs every day; they are surrounded by books, by photographs, by their work-spaces. I'm sure that having an environment that is conducive to their creative process in this way helps their creative juices flow more consistently and with greater vigor than if photography was simply a small part of their life, tucked in a corner, down in the basement, off to the side. They live, eat, and breathe photography every moment they're in their living space. Living and photography are, essentially, the same thing to them.

## *The Secondary Market*

Not long ago, we were amazed to watch three very early issues of *LensWork* sell on eBay for $170—that's almost $60 apiece! These were issues from late 1993 when we first started *LensWork*, when we were giving them away for free! We had no idea that they would be valuable or collectible when we first started *LensWork*.

There's a parallel here, I think, between watching these issues of *LensWork* escalate in value and what happens in the world of art and artmaking.

There is a difference between the *primary* market for any product—artwork included—and the *secondary* market, where things can sometimes become collectible, valuable, historically important, and where people are willing to pay big money for something. The secondary market is also where sometimes things aren't worth very much—as I became aware again this last weekend during our giant townwide garage sale, where I saw lots of artwork for sale for almost nothing. Someday my photographs may sell for lots and lots of money, too. I don't know, I just make photographs now. I sell them for very little because this is just the way things work. But someday, somebody might be willing to pay a lot of money for them.

The point is, if that ever happens with a person's photographs, it has the same sort of reality for the photographer that the sale of *LensWork* issues on eBay had for us. First, we didn't derive any income from them. Throughout all of history, artists have never made income from the sale of their artwork in the *secondary* market. Secondly, we didn't anticipate any income from the secondary market. Shoot, we didn't anticipate any income from the primary market—we gave them away! Thirdly, they sold in a vehicle that we had no idea was even going to exist when we produced those issues of *LensWork*. eBay didn't exist—the Internet didn't even exist! How could we have possibly predicted that?

Exactly the same thing happens when you and I make our artwork. We make our artwork because we're passionate about it. We do our best to sell artwork today because we're interested in getting a wider audience and hopefully paying for some of our expenses and maybe putting some bread on the table. But what happens beyond that in the secondary market is totally out of our control, totally unpredictable, totally *non sequitur* to our process of being creative artists. Similarly, what *LensWork* may or may not be worth someday down the road has nothing to do with our motivations to produce it today.

Whoever sold those three issues of *LensWork* did pretty well. Personally, I like to think that the person who *bought* those three issues got the better end of the deal.

# *The Decisive Landscape Moment*

We were doing a regular portfolio review earlier this week, and in the course of doing so, I found myself looking at a lot of landscapes. It occurred to me that a lot of these were actually quite boring, because I think the photographers maybe don't understand the importance of *the decisive moment*.

Now most of the time, when we hear the term *decisive moment*, we think in terms of Cartier-Bresson and photojournalistic kinds of photography. We think of the crash of the Hindenburg, that great moment that was captured on film. We think of *Falling Soldier* by Capa, that instant that is captured just exactly right. That's a lot of what great photography is about. But even in fine art photography, it is capturing the great moment that so often defines a great photograph. I think of *Chéz Mondrian* by Kertész — that perfect time when the flower is just right, the light is just right. Another Kertész, *Melancholy Tulip*, with that gesture of the tulip hanging its head down. I think of *White Deer* by Paul Caponigro: an image that is in the landscape, but is a specific moment.

Even better examples are *Moonrise Hernandez* by Ansel Adams, or *Clearing Winter Storm*. Both of these grand landscapes captured exactly the right moment. There is even that apocryphal story told by Ansel that he made an exposure, and then went to make a backup exposure, but the light had already disappeared off the crosses and he didn't even make a second negative. In the current issue of *LensWork* (#65), on the cover we have *Bridal Veil Fall in Storm* by Alan Ross. This, again, is one of these moments when the clouds are just right.

In all of these cases, even the landscape, it's the *moment* that makes the photograph special. The moment can be a movement; it can be an atmosphere; it can be a slant of light, a wind, a cloud or, on a longer scale, it can be a season, or even an era. I think of Robert Adams and Lewis Baltz. They show us time that is best comprehended on a different scale, somewhere in the future, somewhat like Eugene Atgét's work — which at the time probably

seemed rather ordinary. Atgét captured these extraordinary moments that defined Paris during his age. His contemporaries probably didn't "get it," but now, with the advance of history, we do.

I don't want this idea to be confused with the *instant*, because that's a little different than the *moment*. Michael Kenna or David Fokos also photograph a moment, but they don't photograph instants. But still, there is a sense of time — and a specific time — in their photographs. Another example is Bruce Barnbaum and his Slit Canyon images. These are not instants — he makes very, very long exposures — but they're instants in geologic time, when the space that he's photographing in these canyons is captured in a certain way. There is a "moment-ness" (if I can invent that term) to his photographs that's not at all an instant.

Far too often, what I see are boring landscapes because they are almost exactly the opposite of a moment. They seem to be *any* moment, or some sort of non-moment. They don't capture anything that's special. They, instead, simply say, "this is what it looks like," almost outside of time. These kinds of landscapes tend, at least to my eye, to be a lot less interesting than landscapes that show me a particular peak moment, a moment that I wish I was there to see.

That's part of the problem with so much landscape photography. We tend to go there and be there, and when we're there, in the landscape, we feel a certain pressure to make a photograph. We do so, but there may not actually be anything special going on at that time — no special clouds, no special light, no special wind, no special atmosphere. It's just a place that we happen to be. Those people who *live* in a place, and stay in a place, and are patient in a place, are more likely to be rewarded with some special moment that they can actually capture on film.

I try to remember this when I'm working out in the landscape. If the scene before me looks like this pretty much all the time, it's going to make it a rather mundane photograph. I have to remind myself to be patient and wait for that special moment in the land where there's something going on that defines a specialness that

the film will capture. That makes a great photograph. Those are the really captivating images, and the ones that are really hard to make because you have to be there with the camera at the time.

I cannot tell you, for example, how many photographs I've seen of Shiprock, New Mexico. Everybody goes to Shiprock to make a landscape photograph. The best one I've ever seen is by a friend of mine, David Grant Best, who waited for just exactly the right clouds. He waited for several days—four or five days, waiting for just the right moment, and he got it. His is a fantastic image, the best one I've ever seen of Shiprock, because of his patience.

Whether it's photo documentary, still life, landscape—no matter what the style or genre of photography—I think the importance of the moment cannot be overestimated. To which I guess we should say "Thank you, Cartier-Bresson" for teaching us this lesson, even in styles of photography that don't look at all like Cartier-Bresson photographs.

## The History of Photography Since 1950

Imagine, if you would, a history of the sport of basketball. If it didn't pay very much attention to, say, the last 20 years, but focused its entire attention on the earliest days of basketball, would you consider that a very complete history of basketball?

Well, that's been my feeling in reviewing a book called *The World History of Photography* by Naomi Rosenblum, published by the Abbeville press in 1997. This work is actually one of my standards in terms of the history of photography, along with Beaumont Newhall's *History of Photography*, but I do have a serious criticism of Rosenblum's history. It's 631 pages long and the final chapter, which is the history of photography since 1950, doesn't even start until page 516! That is to say, of the 631 pages in the book, only 18% of them deal with photography since 1950.

significantly higher percentage than 30% of all the photographs ever made. I would guess that 80–90% of all photographs

ever made in the history of the medium were made since 1950. Yet her book gives proportionally very little attention to that.

In her defense, obviously it's a *history* and it's very difficult to write a history in the midst of *living* that history. From what I understand through the grapevine, her book is basically an expanded version of Beaumont Newhall's book, which was done considerably closer to 1950 than 2006. It makes sense that it might be proportionally skewed towards the early histories of photography. My question becomes: if these two great books on the history of photography are not sufficiently covering the history of photography since 1950, who is? What is the definitive history of photography since 1950? I ask this as a serious question. If any of you can recommend to me a history of photography since 1950, or are working on such a book, I'd love to know.

# *A Deluge of Graphics*

I have, in the past, bemoaned the fact that there's not enough art in our everyday lives. I've advocated that photography become more of an everyday art kind of thing, particularly when it comes to distribution and pricing. The basis of my comments are that there's not enough art in our everyday lives, and I may be wrong on that.

There may be more art than I've been aware of. This really came home to me the other day when Maureen handed me a grocery list of things to pick up while I was at the store. I looked at this grocery list and was suddenly struck by a fascinating parallel. It was just a small piece of paper with a few grocery items written on it, but the paper was cut in a lovely scallop pattern, with a three-dimensional embossing in it so that it had some tactile feel. It was beautifully printed with some floral and butterfly motifs. On this sheet of paper was written the list of things for me to pick up at the grocery store.

It impressed me how similar this humble little grocery list was to an illuminated manuscript from, say, the 14th or 15th

century. How special those documents were, and how common they are today! We take graphic images for granted in our day. It used to be a graphic image was a very special thing, painstakingly made by hand, by a craftsman, an artist who would lovingly (or at least carefully) paint a graphic. Then woodblock prints, stone lithographs, and other forms of the graphic presentation of pictures came about. Now we have photography. In everyday life we're surrounded by this flood of images. I bought a 4-GB card for my digital camera the other day that, if I store JPEG images, will allow me to take 1400 images — on just one card! I also have a 2-terabyte storage system that I have attached to my computer!

Graphic images have become so common that maybe we *do* surround ourselves with art every day. Maybe a little too much art every day. Maybe what we really need is for art to be somehow elevated and more special so that photographs can be seen as something wonderful instead of something mundane.

This may or may not be a good idea, but we're clearly not going to go back to that. The future will likely hold more graphic images than less. And it's a reality that we graphic artists had better understand very well.

## *Where Does the Creative Process Take Place Most Intently?*

It's not very profound to say that photography is a process with a series of distinct and discrete steps. First you have to find a subject, expose a piece of film (or make a digital exposure), then come back into the darkroom, process the film, make the print, do some Photoshop work, maybe do some matting and framing.

Each of those discrete and distinct steps involve a series of decisions. The interesting question is, for your photography, for my photography, *where does the creative process take place most intently?*

For some people I know, the creative process takes place entirely with the camera. It's what they choose to photograph

and how they expose the film that has the manifestation of creativity in their process. Everything else is sort of mechanical. Processing film, making prints, etc., is simply the execution of the creativity that took place when they were standing in front of the subject matter.

For some people, the creative process takes place most intently in the darkroom, or in Photoshop. That's where they're doing all of the really serious creative aspects. What they do out in the field is simply gather raw materials. The creative process is then *what can I do with the raw materials once I've gathered them?*

Then there's the group of people for whom the creative process takes place *after* they've made the pictures. Their creative process is putting the pictures together in some sort of a handmade artist book, or adding text, or doing a layout that involves anything from a digital presentation to a portfolio or an exhibition.

Each of these discrete processes that can involve the potential of the creative process are, obviously, uniquely different. For a lot of photographers, the creative process is modified each step along the way. For me, I've noticed that what has become more and more important is to think about each step as its own creative process that builds to a finished result. Sometimes I don't even   process unfolds. That is to say, the *process itself* is where the creativity takes place. In other projects, I know exactly what it's going to be before I snap the shutter. In those cases, all the creativity is taking place in the field.

As I've begun to think about this more and more clearly, I began to realize how important it is to know where I expect the creative process to be in any given project—or any given image—and work with that knowledge in mind...at the same time being, as it were, open to the "happy accident" which happens more often than a lot of us care to admit.

# An Explosion of Panorama Images

Have any of you noticed, as I have, how popular panorama photographs have suddenly become?

Panoramas have been around forever. There have been banquet cameras, etc. It goes a long way back in the history of photography. But it seems to me that in the last three, four, five years, there's been an absolute explosion of panorama images. I'm sure this has to do with the fact that so many people are now using digital cameras and it's so easy to stitch together images in Photoshop and to make them look seamless. Once again, we have an example of the equipment influencing the aesthetic, and we're starting to see more and more of it.

I predict we're going to see even more panoramas as people become skilled with this a new tool for stitching images together. I happen to think, for us landscape photographers, this is fantastic. The panorama format is such an interesting way to view the landscape. It mimics the way we see in real life.

There is also a fascinating parallel taking place in the movie business, where 16:9 ratios are becoming the standard for movies. We're stretching this rectangle wider and wider. I don't know how far that can be done. I vaguely remember there are people who have been doing panoramas that are 10 inches tall and 20 feet long. I've seen some of these in the past. They get to be rather extreme, even 360° kinds of views.

I think it's very interesting, and very exciting, and I'm going to be particularly interested to see how long it continues to be interesting and exciting before it begins to become trite, overworked, and cliché — like all such trends eventually do in fine art.

# Photographic Truth, Redux Infinitum

Here is one of the things that fascinates me as a person involved in photography. All of us who are involved in photography

know that photographs don't tell the truth, yet everybody outside of photography believes so strongly that photographs do.

We have another example of that this week, with a Reuters news photograph out of Lebanon. The photographer, I assume thinking he wouldn't get caught doing this, manipulated a photograph of the bombing in Lebanon by including more smoke (cloning in more smoke in Photoshop), more clouds, more destruction. In fact, he even cloned in extra buildings that aren't there. People on the Internet got looking at this photograph and realized that it not only had Photoshopped-in extra explosions, an extra black cloud and smoke, but that it was done so badly that it was obvious! In fact, when they started looking and seeing the extra buildings cloned around, it was such a blatant example of the abuse of photographic truth.

But, once again, what this example really shows is that photographs aren't inherently true or not true. The *source* of photographs are always where the credibility of a photograph lies.

I think in this age of Photoshop and easy image manipulation, we're going to see this crop up from time to time, probably repeatedly, until the public begins to realize that, just like any other form of communication, photography is not inherently, in and of itself, truthful or not truthful. It is a reflection of the editorial whims of the person making or distributing the photographs—which is, of course, an obvious truth. Those of us who are involved in photography have known this from about 15 minutes after we picked up the camera and composed our first picture, choosing what goes in and out of the frame.

## Editor, Where Art Thou?

Whatever happened to editing?

I've had a series of CD's show up, of late, where people have sent me their photographs from various events. Some have been snapshots of personal events, but a couple of the submissions to *LensWork* have come in this way, too—CDs filled with, for all

intents and purposes, unedited pictures. Every blasted picture, every single time the shutter was released, regardless of what the lens and the medium captured, they're all there for me to look at—the good ones, the bad ones, the out-of-focus ones, the blue ones, the cropped ones, the half-blinking-eyes ones, etc.

You know, there was a time when we used to edit our photographs, sending our friends, neighbors, and families, only the *best* ones. But it seems that this is, perhaps, one of the casualties of the digital age. Now, rather than doing our own editing, we leave it to someone else to edit what's important and what isn't important, what's keepable and what's not keepable.

For family snapshots, maybe this is okay, maybe there's nothing significant about it. But when I start to see it happen in the world of fine art photography and the creative process, I get a little worried. I think that along with making photographs, one of the most important skills a photographer can have—as a matter of fact, perhaps *the* most important skill a photographer can have—is the ability to edit one's own work—to know what's good and what's not good, what should be included and what should be excluded from the final project. When it's all said and done, we need the about which we're going to say, "this is my artwork," and which images are destined for the round file, or electronic oblivion, as it were.

It's an old cliché that the most valuable tool in the darkroom is the garbage can. There is absolutely no reason why this doesn't apply even more in the world of digital photography, where the seduction of larger hard drives and digital memory cards (I'm convinced) is the work of the devil. It seems that to be a really terrific photographer, one needs to know a lot more than just composition, technical expertise, and timing. It's just as important to know which ones to throw away.

## Used Books, The Classics, and Photography

I love books—photography books, art books, books of

short stories or histories, and in particular novels, particularly the classics. I've been a Dickens fan my whole life, as many of you know.

I can't help but notice every time I go into a used bookstore, where I love to spend time, that I find lots and lots of really gorgeous hardbound books — nice big, fat novels, 600 pages' worth of creativity and storytelling, available for anywhere from $8 to $10. An expensive novel might be $12. I rarely pay more than $12 or $15 for a novel that's a used book. And a good novel will take days, or weeks, sometimes months to get through. I'm working through, of all things, *The Pickwick Papers* again right now and enjoying the heck out of it. It's taken me several weeks to read it. (I'm actually doing it as a book-on-tape, so I'm listening and reading at the same time.) It's a wonderful experience and it takes quite a while to get through a big, beefy novel like that.

So how does that compare to a photography book, or to an individual photograph? Why can I buy the best literature throughout all of history for $10 or $12, that takes me weeks to get through, and enjoy it? At the end of it, I'm sorry the book has come to a close. I enjoy every single page, every single paragraph. They're wonderfully crafted things. And is it at all odd that a photography book — which cost a lot more — I can get finished a lot faster, and it leaves me almost invariably with a less fulfilling sense than reading a good story?

Don't get me wrong. I love photographs, I love photographic books — they're wonderful things. But somehow there is this disconnect in my mind between what it is that I have to pay for that experience and how much I get out of that experience, and how much I pay for a really great novel as a used book and how much I get from *that* experience. As a photographer, I can't help but wish that they were a bit more equitable.

# *A Book I Won't Be Purchasing*

The seduction of technology reached a new high this week—or maybe I should say it hit a new *low* this week. I saw a new book that was just released entitled *Image Sharpening in Adobe Photoshop RAW Converter CS2*, or something like that. It's an entire book about how to sharpen your images as you open the RAW file in Photoshop. A whole book covering, I'm sure, every single detail of that relatively obscure technical process.

It's important—I mean, we all sharpen our digital images. There's no question it's an important thing and we all need to know how to do it, etc. But a *whole book* written about that? About something that is changing so rapidly? About technology that's still in the midst of evolution? And someone's written a *whole book* about it? Have I mentioned that it's an *entire book* about this one particular thing?

For some reason, I never imagined, when I got involved in photography 35 years ago, that it would be such a technically detailed, incredibly obtuse and arcane pursuit when it came to the technological aspects of photography. I guess I'm just completely out of touch because, to me, photography has always been about *photographs*. It's always been about what shows up in a photograph and how it affects our thinking, our minds, our emotions, and how we communicate with one another. It never dawned on me that I would need an entire book to show me something as simple as how to sharpen my photographs on the computer.

But then again, I guess that's why I'm the editor of *LensWork*, instead of *Photo Technology Today*.

# *Artmaking, Podcasts, Popularity, and Being True to Yourself*

One of the most interesting things about doing these podcasts is the instantaneous feedback I get from the listeners out there. They have the opportunity to either agree or disagree with what

I've said — and they let me know that! Often I get quite a number of e-mails from people saying *atta-boy* or *you jerk*. It occurs to me that this is not totally dissimilar from the process of actually making artwork.

When you produce something, when you produce any-thing — be it a photographic project, if you publish a book of your photographs, or an essay of your ideas, or an art photograph for the wall, or a podcast — you will be criticized by people who will either agree or disagree with you. You'd better be a little bit thick-skinned. This became clear to me as I started to think about what I wanted to do with these podcasts, because the natural human temptation that all of us have (me included) is to try to please people. No one enjoys confrontation (well, maybe not no one, but *most* of us don't enjoy confrontation). The temptation, the seduc-tion, is to try to say things in a podcast, or produce artwork, that most people will appreciate and will gain the maximum amount of approval for what you've said, what you've created, or what you've done.

Of course, in this age of diversity, amongst all kinds of people and all kinds of opinions, and lots of variations in how to approach anything — from art to politics to religion to pod-casting — there are lots and lots of different ways to think about things. There are lots of opinions. One of the challenges is *which group do you choose to appeal to?* Whose favor do you want to curry? Who is it that you want to give you the *atta-boys*? And if you work very hard to please those people, you will likely simultane-ously disenfranchise (or insult) some other group, because that's the nature of the world today. So, we try to please everybody.

The problem with that — whether we're doing podcasts or making artwork — is that we will tend to get sucked into that great middle ground where everything is just blasé and gray, where we all agree, and there's nothing interesting and exciting about what's been produced or what's being said. Nothing is challenging. There is a relationship between the maximum amount of approval and, in some regards, the least interesting statements and least interesting artwork. If we're only producing

or saying things that everybody already agrees with, there is no reason to say them or no reason to produce them. It's not really inventive or creative. The other side of the coin, however, is if all you're doing is saying, or producing, or creating artwork that is intended to create shock value, or intended to be controversial (people like Madonna come to mind) then that ends up being sort of shallow at the other end of the spectrum. It's one of those businesses about "If you're bound by the chains of gold, or bound by the chains of iron, you're still bound by chains."

It seems to me that the only way to avoid this trap is to be true to yourself, to say what you want to say in a podcast, or produce what you want to produce in artwork, and let the chips fall where they may. At the very least you have the integrity that, I guess, you can sleep at night, and you can know that what you produced is really *yours*—where it really is a manifestation of you as a unique individual. The world will either accept it or not accept it, based on the whims of fashion at the time—or whether or not you happen to be in front of an audience that's receptive. There are so many variables, you can't possibly predict how an audience is going to respond.

Of course, we've all experienced this in the creation of our artwork, and had to come to terms with it: do we make things for the clients, or for the customers, or do we make them for ourselves? Or do we find that middle ground in between, where we try to satisfy both? It is a very dicey tightrope to walk. No one wants to be universally disregarded and ignored because they're not producing anything of interest. At the same time, if that's our objective (to be universally adored and admired), we're not going to produce anything that has any merit. It is a difficult process to find that spot in the middle where we are both true to ourselves and, at the same time, not totally isolated. (No man being an island, is it were.) It's a difficult place, but it is part of the process of being an artist (or a podcaster).

For me, this has become another issue based on the occasional flamethrowers who respond to my podcasts with rather, shall we say, vituperative e-mails and whatnot. I find that ultimately

I can't let those people influence how I go through life because, if I do, all I do is become *them* instead of *me*. And so if you don't like my artwork, then that's okay. It's not necessary that you do. Maybe, if I'm lucky, you'll like the next project that I do. My responsibility is to keep producing them and being true to myself, allowing my creativity to blossom as it will. If you don't like my comments and my podcasts, it's sort of the same situation. You have the option to either say, "Well, that's Brooks, and that's his opinion, and let's move on"—and take what value you can, or not listen. As a producer, what I have to do is make sure that I'm not influenced by trying to find that great non-controversial center where the maximum number of people agree with what I say. Doing so, whether it's in art-making or podcasting, would be the only way to guarantee that what you make is something that is probably mediocre, likely not true to yourself, ultimately banal, and probably boring.

I guess what I'm proposing is that both art-making and pod-casting are not popularity contests, but rather something that has more to do with personal and individual truths, which may or may not be popular, and that's just sort of the way it is.

## *The Power of Deadlines*

This last weekend we completed the preproduction phase of *LensWork* #66 and sent it off to the printer. It's being printed this week, and then will be sent off to the bindery. In the spirit of true confession, I'm kind of amazed—*LensWork* #66!

There was a time in our history when I really doubted we were going to get into the double digits. But, like I say—in the spirit of true confession—I have to also admit that I'm not sure we would have completed 66 issues of *LensWork* if it hadn't been for the power of deadlines.

As an artist and a photographer, you'd think I would understand this from my role as editor of *LensWork* and employ it in my artwork. I still haven't quite learned the lesson. There is

something magical about having a committed deadline — one in which there is an expectation from the audience, or your clients or whomever — that you will be producing this thing. The power of that deadline allows us to focus our energies and not to allow ourselves to be distracted; the discipline that it creates is a marvelous tool. I don't know why I'm not using that more effectively for my own artwork. I need to think about this more carefully.

I suppose the reason to bring it up in the podcast is because *LensWork* is such a fantastic example of the power of deadlines working their magic on a relatively undisciplined individual like myself — that it says something about the power of a deadline to help us create something and to "get off the dime." I envy those people who don't need deadlines, but clearly I'm not a part of that elite group.

## *The Time Frame of a Project*

There's a very interesting thing that's happening relative to the production of photographic art projects and time — or maybe I should say the *time frame* in which the projects are produced.

It used to be that a photographic art project (I think of the great portfolios that Ansel Adams did) were produced over a fairly long period of time — sometimes years, or at least months, very frequently over decades. The finished portfolio of fine art photographs would be a collection of things from a similar theme that took place — photographically speaking, anyway — over a very long period of time. That's changing. I'm not sure if it's changing because of the nature of the projects that are popular today, or if it's the technology, but I suspect it's more likely the latter than the former. The technology today, particularly those people who are shooting digitally (or at least *printing* digitally) are finding the speed with which they produce work has increased dramatically. It is sort of like everything else in life that is so much faster now than it was 50 or a hundred years ago. You've probably all heard that statement that we live as much experience

in our lifetime as our great-grandparents did in the equivalent of seven lifetimes. Well, that's true for photography as well as everything else. Here's an example of that.

I've just been reviewing a new beta software from Adobe called Lightroom. I've been looking at some of the various tutorials about this new software. One of the consistent ideas that has come up about Lightroom is that it's necessary for photographers to have a tool (of which Lightroom is the proposed solution) that allows them to manage the number of photographs they return with from a given shoot. The operative question is: How do we manage the hundreds if not thousands of images that we make during a very short period of time? This is such an odd question to me and I can illustrate it best by comparing it to an experience from my past.

I did a project in the mid-'80s. I had a lot of time on my hands that summer and I decided to go to Eastern Oregon for 26 weekends in a row to photograph. To prepare for that, I purchased (found used out there in the world) eight Graphmatic 2¼x3¼ sheet-film holders for my old Arca Swiss monorail view camera. Those eight Graphmatics each had the ability to hold six sheets of film. I could go for an entire weekend with 48 exposures. I'm not sure I ever came back with all 48 sheets exposed. So, a weekend's worth of work for me was always less than 48 exposures.

Now comes the digital world and digital cameras and a product like Lightroom. I'm hearing in these tutorials that I've been watching of late how people will come back from a shoot with 500, 1000, 1500, 2500 images that they have to upload, organize, sift through, etc. I'm amazed how this change of time frame is affecting the production of artwork. Last October, I did that little project called *October Seas*. During a period of a long weekend—five days or so of photographing—I produced a portfolio. In those five days, I shot about 800 exposures. I understand the need for this new piece of software that will allow me to upload, organize, and start working with those images. Then I can whittle down, whittle down, edit, etc., and get to

the final product—or to the individual images that I'm going to keep from that shoot, or that weekend out with a camera.

It is amazing how that time frame is changing, and I'm suspicious that it's changing because of the nature of the tools. More and more, I'm seeing photographic projects where the photographer worked for a day, or two, or three (no more than a week) and ends up with a body of work that is quite extensive, quite interesting, and quite a fascinating collection of photographs that hold together. It's the kind of thing that I used to see 20 years ago that was the result of a year, or two, or three, of intensive work from a photographer. I still see that from time to time, but I'm also starting to see the short bursts, and it's a fascinating change to observe, particularly as an editor searching for content for *LensWork* to see how these projects are sometimes developing so quickly.

## *Working with Professionals Professionally*

Most fine art photographers, when pressed about it, will admit that they're interested in somehow "making it" in their career and with their artwork. That is to say, they're interested in doing a book of their work, or having an exhibition, gallery representation perhaps, they'd like to be seen in a museum, or maybe they just want to have their work published in something like *LensWork*. Most fine art photographers don't want to be an island working by themselves with no audience.

It's worthwhile taking a moment to think about, first, what it is that you mean by the term "making it" relative to your career. Even more importantly, what are the steps necessary that you need to do—that you need to *accomplish*—in order to help you achieve your goals in order to make it? Because, you see, if you want to have a book published, or an exhibition, or be in a magazine, it implies that you need to work with others. The other people are going to be involved in helping you achieve those goals and objectives. Of course, as the editor of *LensWork*,

I am brought face-to-face with this issue almost every day be-
cause I work with photographers to help bring their work to
our readership. The level of professionalism that is important,
necessary, or required when working with others should not be
underestimated. That is to say, if you bring an incredible amount
of professionalism to the creation of your artwork, why would
you tolerate any less professionalism in the presentation of your
artwork to others who are going to help you achieve your goals?

You would be amazed how many submissions we get here
at *LensWork* that are not professional, that do not include
a business card, for example. Everybody seems to include con-
tact information, but you'd be surprised how many times it is
wrong, or we don't have a zip code, or the e-mail address is no
longer valid — and that's just the start. Most often, we don't get
a biography of the photographer. It's important to know about
you. What we do get, almost without exception, is the *curriculum
vitae*. Well, that's terrific if what you're trying to do is brag about
your education, because that's typically what's in that document.
It tells us where you went to school, and what honors you re-
ceived. Sometimes people expand that to tell us what jobs they've
had. But that doesn't tell us about *you*; that tells us about your
accomplishments, or that you've graduated, but it doesn't tell us
about you, as an artist.

A biography is a different document than a *curriculum vitae*.
You should spend time preparing it. It's important. It's exactly
the same as for your artist's statement. I'd guess about a quarter
of the submissions we get at *LensWork* don't have an adequate
artist's statement, and worse than that, I will tell you that 100%
of the artist's statements we receive are not publishable in the
form they're received. They're either not clear in their writing, or
they have misspelled words, or it rambles, etc. You would think,
after all the issues of *LensWork* that we've published, people
would know what kind of materials we're looking for, and about
the length of the biography, and the artist's statement that we
need. But we rarely get that. Why is that? It's because, I think,
photographers are not paying the same kind of attention to

the professional statement of who they are, and what they are, and why we ought to publish their work, etc., as they put into the work itself.

Speaking of the work itself, when you send work for publication (whether it's prints or scans) you need to make sure that you're sending the right thing. Don't send unfinished work prints. It's also not appropriate to send matted or (God forbid) framed gallery exhibition pieces. You should develop, the way all professionals do, a set of "reproduction press proofs." These are prints that are printed to the exacting degrees that you would like them to be seen in a publication. They're perfect prints otherwise, but they're unmounted and, almost without exception, unsigned. It's okay to say "Reproduction Proof Only—Not for Sale—Return to Sender" with a stamp, or something like that, on the back of the print.

If, on the other hand, you send scans to your publisher, make sure that the publisher knows your color specs; make sure your monitor has been properly calibrated when you prepared those scans. Make sure the publisher knows whether or not they've been sharpened, or to what degree they need to be sharpened. Make sure that you're sending the proper files in the proper format, and to the proper pixel dimension—the size the publisher needs. Be sure to include a list of the prints you've sent, the titles that you apply to the prints, and whether or not the titles should be used in the publication.

All of this has to do with being perceived and presenting yourself professionally. There is absolutely no reason why your presentation to a publisher, to a gallery, or to a magazine should be any less  polished than the presentation of your artwork offer to an audience. Both are a statement of who you are and what you are, and a reflection of the care and concern with which you create your work.

# Katrina and Photographic Ethics

This week, during the anniversary of hurricane Katrina, there is an ethical issue relative to photography that I've been thinking about a lot, and thought I'd bring up in this podcast. I have to admit, right up front here, that I don't have any answers, but I do have some questions that I would propose are well worth thinking about, that have to do with photographic ethics.

I've seen a lot of photographers sort of racing down to New Orleans to photograph the devastation down there. There's been quite a number of photographers who've contacted us, submitted portfolios, etc. to show us their work of Katrina. I have to admit, there's a little hint of an "ambulance chasing" mentality about this that bothers me just a bit. That is to say, the tragedies surrounding Katrina are so very devastating, and so very personal, that I struggle a little bit with photographers racing down to photograph other people's sorrow and misery.

In one form or another we've all, as photographers, had to deal with this issue: *When are you crossing the line of good taste or ethical behavior?* For example, do we photograph homeless people in a drunken stupor, sitting in the doorway on some street? Or is that a violation of their privacy, and a crossing of an ethical line to exploit them in their misery for the sake of our artwork?

The same sort of thing strikes me as happening with hurricane Katrina and all of the photographs that are being made down there. Are they exploiting other people's tragedies for the sake of making photographs that are not necessarily documentary, or news photographs, but are being made more as personal fine art projects?

I've seen a number of photographers who have had no hesitation, evidently, to walk into people's homes—abandoned homes, true—that is to say, the people are not there anymore, but that doesn't mean they're not coming back; that doesn't mean that they've walked away from their homes. They're just not there now because the home is not livable. Yet photographers are going into these homes and photographing them. I can't help but

wonder how I'd feel if someone was walking into *my* home, photographing *my* possessions, without *my* permission — in the midst of my personal loss and personal tragedy. This somehow feels like it might possibly cross an ethical line.

Again, I'm not sure I know exactly how I feel about this, but I do feel nervous enough about it that I'm not sure I'd want to do it myself until I really came to grips with the ethical questions that are involved here and could commit myself to photographing there with conviction that I was not crossing an ethical line. At this point I'm not positive it *doesn't* cross (at least for me personally) an ethical line that I'm uncomfortable with. These are, after all, their private property, their private homes, their living rooms, their bedrooms, their possessions, their loss, their tragedy. As an outsider I'm not sure it's appropriate for me to invite myself in, and to use their loss to make my artwork.

I can understand how some of you could feel considerably different about this, and I'm certainly not going to condemn people for doing it. What I am trying to point out is that it is one of these issues that each one of us — individually, and in our own minds and hearts — needs to decide for ourselves when it comes to photographic ethics. Where do we choose to draw the line of good taste and ethical behavior relative to creating our own artwork? This situation down in New Orleans seems to be a classic opportunity for all of us photographers to think about it more deeply.

## *Podcast from Wyoming #1*

Hello everyone, and welcome to what is going to be a quite different podcast for me — and I have to confess right up front a bit of an experiment in podcasting. I'm actually on vacation this week, and I'm photographing in Central Wyoming at a place called Hell's Half Acre, which is about 40 miles west of Casper. I came through here about ten years ago, and at the time there was a restaurant actually located on the very edge of this giant

bowl in the ground of about—and I'm guessing—maybe 300 or 400 acres of the most bizarre geological formations that one could want to photograph. There are lots of hoodoos, lots of bentonite erosions, and all kinds of fascinating lava rocks. It's just a really interesting place, with striations of red and a light tan and orange, and it's as though this strange little bit of land was sculpted through a gazillion years of rain and wind. It's an absolutely fascinating place. Well anyway, I came through here I believe in 1996 on a photographic trip that did not involve this particular location. But I stopped to grab a bite to eat, and at the restaurant overlook I peered down into Hell's Half Acre and was fascinated by what I saw. I decided it could very definitely be photographed. I did manage during that trip to get one afternoon to come down and photograph in the setting sun, and made some interesting photographs which I've set aside all these years. I thought I've got to get back there someday, and someday has arrived. So here I am, sitting in the middle of this geologic formation with my camera and my long-time photographic friend and buddy, Joe Lipka. We've been out photographing for a week in September every year now for I think maybe 18 or 19 years, something like that. This is our September trip this year: to photograph in this bizarre landscape. My intent during this week is not only to photograph this landscape, but I really am hoping to complete a portfolio of this work similar to what I did with *October Seas* last fall. I may or may not succeed at that. I have a lot of photography to do between now and the end of the week, so I'll keep you posted how that's coming along.

In the meantime, it was suggested that I consider this as an experiment in podcasting. They will be somewhat less formal than my normal podcasts produced in the office; certainly more casual in terms of the quality of the recording, but I think we can overcome limitations there. They may even look a little bit more casual in terms of format, since Joe and I want to have some conversations that we will share with you later in the week about what we're doing. I'm also going to do a little video presentation showing this area and my photographic approach in this

landscape. For anybody who might be interested, that'll be in a future issue of *LensWork Extended*.

But in the meantime, I'm going to take the opportunity this week just to talk about miscellaneous issues that occur when one is out photographing in the field. So my first comment is: *Take less gear than you think; it's always heavy in the desert!* I came down this morning with a full complement of video gear, and two tripods, and cameras, and microphones, and audio recording equipment, and it's not easy. I may not get as many videos from down here as I think. But it is necessary to take *more* than you think in these kinds of places. Having done this kind of photography for many, many years, I can tell you that it's not a bad thing to anticipate what might go wrong; to have back-ups if you need them; to carry extra batteries, extra film, extra holders, even an extra dark cloth if you can manage it. There are always things that will happen when you're out and about photographing that you cannot anticipate. And so this morning's particular lesson is: *The most valuable thing you can take is tape.* Because when I got here I found out that my OptiVisor—the magnifying loop that I wear on my head for viewing the little screen on my camera—was broken. For years I've used an OptiVisor rather than a traditional loop, even in the view camera days, because it left my hands free. So, the OptiVisor was broken and I needed tape to repair it. How easy it would be to put a roll of electricians' tape in my vest, which I'll certainly pick up at Wal-Mart back in Casper, when we're back in town. Tape is a handy thing for doing repairs, and in this particular case I sure could've used it to repair my OptiVisor.

Another comment I thought I'd interject in this very first podcast is how excited I am to be back here, and how interesting the pattern is that I've noticed in my working life as a photographer now for 35 years. Not very consciously—I wish I *had* been more conscious about it—I find myself constantly looking for places like this that interest me photographically, that I tuck away. And you know, a lot of times my best photographic work comes when I return to a place that I've maybe checked out somewhat

briefly, maybe just been introduced to, maybe only had a short amount of time. But somehow I'd sort of tuck that away in my memory and think, *Someday I'm going to go back there.* I wonder if it has something to do with the subconscious mind thinking over the course of months or years about that place, and about what one could do photographically in that place. But it happens a lot to me. Ten years ago I was in this place for the first time, and here I am back photographing it and seeing more photographs than I can probably make during the course of this week. It may be that it's just a magical place. It may be that I've been prepared to see it because over the course of the last ten years, from time to time, I've dug up contact sheets that I made that first after-noon and reviewed the images, and refreshed my memory with what this landscape is. I find myself here now, sort of prepared visually to make images here — and with a specific end-product and goal in mind, and a certain aesthetic and a way that I want to approach this photographically. It's not a bad strategy, and one I wish I would have been more conscious of years ago. For some-body like Edward Weston, who lived on Point Lobos, maybe that strategy was rather obvious — you just go back and photo-graph and photograph. But for me, returning to a place like this has a certain kind of magic. It's not a bad thing for me to even strategize on in the future — that when I'm driving, when I'm off on a family get-together or a business trip, or whatever it may be that may have nothing to do with photography — to keep my eye out for places that I might want to return to because they have photographic potential.

One other thing I wanted to mention here in this first pod-cast, too, is that no one has photographed this area that I can find. I did an extensive search on Google and the Internet to try to find someone who has photographed in Hell's Half Acre here in Central Wyoming. I came across some touristy pictures in flickr.com and that kind of thing — but nobody that I could find had approached this little bit of landscape from a fine art point of view, which is really a shame, because it's a gorgeous place. It may be that there are many, many people who have done it

and I'm just unaware of it. Maybe if I'm lucky through this pod-
cast I can make connection with those people, because I'd love to
see their work and meet a fellow photographer who's as fascinated
by this little spot of the Earth as I am. At least for this week, Joe
and I kind of have this place to ourselves. It's a very, very inter-
esting place, and I hope maybe when I get back and get a chance
to post some of the images on my website that other people will
find it as interesting and fascinating a place photographically as
I do. So if you happen to know anybody who knows this place, let
me know. If you are someone who has photographed here, drop
me an e-mail. I'd love to hear what your experiences have been
here photographing, and maybe see some of your photographs,
too.

So that's what we'll be doing this week—podcasting
somewhat casually, and I hope you'll indulge my rather infor-
mal ramblings on this particular trip because, folks, I'm on
vacation—and I'm just going to have a hard time taking myself
too seriously when I'm out here having this much fun. So we'll
talk with you tomorrow. Bye!

## *Podcast from Wyoming #2*

So, it's Day Two on my trip here to photograph Hell's Half
Acre in Wyoming. I'm about 40 miles or so west of Casper,
Wyoming, in this little spot of weird geology known as Hell's
Half Acre. Today is just another fabulous day; very light clouds
coming in overhead, creating this giant soft-box in the landscape,
and clearing out from time to time to give us these wonderful
shadows. This is such a spectacular landscape—particularly
working in the intimate landscape as I'm doing for this portfolio
project. Every time you turn around there's another composition.

Which brings me to my subject of the day, which is turning
what is, for all intents and purposes, the chaos of the landscape
into something that is compositionally clean and organized pho-
tographically. I have to be honest: when I'm out here looking at

this kind of landscape and seeing the chaos that dirt and rocks and inorganic non-aesthetic materials make, I'm frequently reminded of Edward Weston. When pressed about composition, he simply said that "Composition is the strongest way of seeing." I find myself coming back, and back again, to that really simple definition. When I look at something, there always is — if I really take the time, which is what art-making is — a way to find the strongest composition. If I take the time to look at it, and walk around the subject, and examine it from different angles, and step closer or further back to simulate different focal-length lenses, and visualize it in a lot of different permutations, I'll find it. What I find, almost without exception, is that there is one way, or sometimes two strongest ways, of seeing a particular shape in the landscape. Matter of fact, I can do that with almost any shape in the landscape — many of which don't make interesting photographs — but there is still a strongest way of seeing them.

I am also reminded of an odd bit of art history. It was the aesthetic in Egyptian painting to always present things from their most advantageous point of view. That's why portraits in Egyptian painting show the legs and the lower half of the person from profile, and the nose from profile, and the hands from profile, but they show the trunk — the abdomen of the subject — and their two eyes as though you're looking at them straight on. To us, these look very bizarre and strange and contorted, but to the Egyptian aesthetic it made perfect sense, because of their insistence that a painting always show objects from their most advantageous point of view.

There is a painting that I remember Sister Wendy [the author of many books on understanding and appreciating painting] talking about. It showed a little pond in a palace courtyard or something, and the ducks that were standing at the edge of the pond were all facing with their feet towards the pond, while the point of view from the painting was to look *down* on the pond — because that's the most advantageous point of view to look at a pond. But the ducks were all *facing* the pond, so the ducks on the bottom of the pond were upside down, with their feet towards

the pond and their heads away. The ducks on the top had their feet towards the pond down, and their heads on top. The ducks on the left had their feet towards the pond, and the ducks on their right had their feet towards the pond. It was a classic illustration of how Egyptian painting always shows things from the most advantageous point of view from literally, *literally*, the point of view that you see it.

Well, here I am out in this desert landscape looking at these fantastic rocks, and I'm thinking of exactly the same thing: how is it that I see these rocks from one angle to show them off the best? And for some reason, that way of thinking fits best with my way of art-making. I tend, I suppose, to lean towards that school of art that is involved with truth and beauty, showing off things to their best, being as complimentary and as humble a servant (if I can use such language — to be a humble servant to the subject that I'm photographing) as I can; to care enough about the rock to show it at its best; to care enough about the tree to show it at its best. And that, I think (in my interpretation, anyway) is precisely what Weston was getting at when he talked about the strongest way of seeing. It may be a misinterpretation, or it may be flippant to say — that it is the most complimentary way of seeing, or perhaps even the most expressive way of seeing — but that is our task as artists, as photographers, to decide how it is that we want to express our relationship with the landscape, our relationship with the subject matter, or whatever it is that we're photographing. In my case it is this desert — to make it look as wonderful as it is, as real as it is — because in my way of thinking wonderful and real are the same thing. Which represents probably a statement of philosophy that is a little heavy-handed, considering I'm sitting here in the dirt.

Well, those are my rambling thoughts from Hell's Half Acre in Central Wyoming. Thanks for indulging me in my vacation podcasts!

# *Podcast from Wyoming #3*

Hello, folks. It's Day #3 of my photographic adventure here in Hell's Half Acre in Central Wyoming, about 40 miles or so west of Casper. I'm taking a little break from the morning's shoot, and just thought that I'd bring you up to date. I must admit it's a little odd having all of you with me on vacation, but it's kind of fun and I hope you're enjoying it.

The Random Thought of the Day is how important feedback is in the field. I did a portfolio, oh gosh, I think I did that in the late '80s, it was called *The Valley Spirit*. It was a project that I did specifically because I had built for me a Polaroid back for my Arca Swiss 6x9 view camera. It was the first time I ever had feedback in the field, and I was amazed at how it changed the work that I did in the field—because I could see immediately what was there, what I needed to do, and where I might want to take a photograph or do something a little different than what I thought I had wanted to do with it. I had the ability to do that in the field because I was seeing my results immediately. Once again I'm experiencing that same kind of thing, as I'm out here in Hell's Half Acre with my digital camera. I had an odd experience last night when we got back to the motel room, when I started looking through the images that I had made yesterday. My approach in the field, generally speaking, is to be quite intuitive. I try not to be too predetermined in what it is that I want to photograph. Obviously, with a project in mind I go out with a general direction—you know, some ideas about what I want to accomplish—but not too specific. That is to say, I want to give myself the ability to be intuitive in the field, and react and respond. It's funny, because as I've gotten older and photographed more, I've found more and more that I can trust that intuitive response to the landscape, which I didn't before. And now that I've become more comfortable with that—as age and confidence are built—I've discovered this really is the best way (for *me* anyway) to photograph. It is best for me to be just absolutely intuitive, and go with the flow. But an important part of that is at the back

end, when I get a chance to look at what I've done. Then I put on my more critical and analytical hat, and see what I actually produced in that intuitive process.

Well, yesterday I found one particular subject and allowed myself to be intuitive with it. I was excited about it—obviously, if you're not excited about something you won't go photograph it—so I was excited and photographed it. When I got back to the motel last night it was the image that absolutely stood out amongst all the others—because of the way I had exploited the natural angular light that comes through all these hoodoos and odd geological spaces and shapes and whatnot. It was just a fabulous image. I hope it's as good when I get back and start trying to turn it into a finished print. But what was interesting is how looking at that image last night in the motel room got me thinking about what it is that I'm doing, and has influenced me *today* in the field. So now I'm looking for more of those kinds of opportunities. As I wander around today—in some of the same areas, and some different areas than where I was yesterday—I'm essentially looking for that same kind of opportunity. I'm being influenced by the image feedback I had last night. And, of course, the other feedback I had was from my photo partner, Joe Lipka, who's here doing work too. We looked at each other's images and made some comments. He is a trusted photo partner insomuch that I've known him and been photographing with him for 20 years or so. That's a valuable relationship to have. When you go photographing with someone whose opinions you can trust and listen to, and get some good advice —not that you'll take every bit of advice that they offer, but at least when they do offer advice, or something of interest—it's valuable feedback to have. It's that opportunity, I guess, to get feedback—and to have that feedback influence your work—which is, I think, an important part of the creative process. Out here photographing today I'm really glad that I've got both those forms of feedback: the feedback from analyzing the images that I've captured on my digital camera (by the way, those of you who shoot analog can do this just as easily with Polaroid film), and the feedback that I get

from my friend. It's a different kind of thing when you get that feedback here in the field than when you get it back home, after you've finished the body of work, and you have the exhibition prints all matted and ready to go. In the field you can actually *do* something with that feedback. I find that particularly invigorating from a creative point of view. So, I guess if I had any advice it would be to strategically think about that as you're working, and try to develop ways to include feedback in the structure of your projects or assignments when you're out in the field.

Well, "break time" is over. Back to work! Talk to you later.

## Podcast from Wyoming #4

So the title of this podcast is *Waiting For The Light*. I'll give you one guess what I'm doing! This is another of my communiques back to the civilized world from Hell's Half Acres, about 40 miles west of Casper, Wyoming. This is our fifth session down here in this strange bit of geology. I set up to photograph some of the little hoodoos that are making a pattern that looks almost circular, almost meeting-like, but I need just a little different light on it. The sun is heading down over the rim of the canyon back behind my shoulder and I'm just waiting for the light to come in—so it's got me thinking about light.

I'm going to mention here that I disagree with the bumper sticker wisdom that is commonly heard in photographic workshop land, and by the really great photographers. Matter of fact, when I interviewed John Sexton just a few months ago he mentioned that photography is about light—and I've always disagreed with that premise, that photography is about *light*. I've always felt that photography is not at all about light, although light is clearly the primary tool that we use to make photographs. What I understand by the phrase "about light" is that light is the *subject* of photographs, and I've always felt that *life* rather than *light* ought to be the subject of photographs—the human emotion and human passion, and communicating with each

other, and exploring the world and our place in it, and our feelings about it, and our feelings about one another—those are the things that photography is about. Light is simply the *tool* that we use to express what we have to say or attempt to communicate graphically what it is that we want to with light as the primary tool. To me, to say that photography is about light is the equivalent of saying that poetry is about verbs, or that a novel is about words. Good writing uses words and punctuation and dialect and all of the tools of the written word to communicate what it is that the author wants to communicate—but it's not about *words*. Words are simply the tool. My feeling is exactly the same in photography: that light is the tool. So I'm waiting for the light—not because the light will be better seen as light when it gets into the right position for this photograph, but rather that light, and more specifically the shadow that it will cast, will create a more powerful photograph, I think (I hope), of this particular subject matter. I'm waiting for a more dramatic moment, a captured moment in time that will more powerfully express what it is that I feel about what it is that I'm photographing. So, light is my tool, and in the landscape, it's a tool that demands humility and patience—and that is, in my way of thinking, one of the great joys of using light in its natural form; it forces us in some regards to acknowledge its supremacy in creating what it is that we're trying to do as photographers, and it asks us to be humble and accept it, or to be patient and wait for it, because it takes its own time.

So that's what I'm doing here in Hell's Half Acre. Talk to you tomorrow!

## Fits and Starts

Fits and starts, fits and starts, fits and starts, as it were…

For those of you who follow these podcasts you'll notice that my last entry was September 13th, when I was in Wyoming. Today is October 19th. It doesn't take a genius to figure out

that I've been back about a month from my trip to Wyoming, and have been (as far as these podcasts are concerned) silent. I suppose I could use some excuses, like: the photography in Wyoming was particularly good, and I got so busy photographing that I neglected to do the additional podcasts that I had intended to do—which is true, but not an excuse. And then when I came back from vacation I had a week's worth of stuff piled up on my desk which I had to deal with—which is true, but not an excuse. And then I could say that we had to deadline *LensWork* #67, and I had four interviews to conduct with photographers, and the layouts to complete, and all the work that is required to produce an issue of *LensWork*, including an Editor's Comment I had to write—which is all true, but not an excuse. And then we had *LensWork Extended* #67 to prepare to send off to the master duplicators so those CDs can be created for the subscribers—which is also true, but also not an excuse.

Fits and starts, fits and starts, fits and starts. In all honesty, this is not unique for me, because when I look back over my photographic career I find that fits and starts are more common, more typical, than they are atypical. It makes me wonder about what there is in this process that I should pay attention to. Well, by absolute sheer coincidence, when I came back from Wyoming, I picked up a book I've been meaning to look at for a long time and just hadn't gotten around to it. You know I have rather odd reading habits. I love the classics and all that stuff. I have never read the great classic called *The Decameron* by Giovanni Boccaccio. This is a book that was written in 1348, so it's about time I got around to it. And what d'you know, in the very first few pages of this book I read: "When things are not organized they cannot long endure," which seemed to me to be a statement aimed directly at the heart of my procrastination. So, with that in mind, I'm putting into effect a plan to change the way I do my podcast recordings. I'm setting an appointment with myself so that I can record them on a regular basis, and you, my dear friends, shall be the judge as to whether or not such discipline can be invoked with regularity. The reason I mention this relative to my podcast

is because it obviously makes perfect sense that exactly the same thing can be said about creating one's art, and doing photography. Fits and starts. Fits and starts have plagued me in my photographic career for 30 years. I've had times when I've gone a year or more and not made any new images, or months and not been in the darkroom.

I remember in the early '70s I was plagued by this, and decided I needed to do something specific to get in the darkroom on a regular basis. So I decided I would set up a schedule, and thought that what I would do is spend every Saturday in the darkroom. Well, it didn't take long to figure out that this just wasn't going to be practical. There are certain obligations in life that I had to deal with—everything from mowing the grass to taking the kids to soccer, that kind of stuff. So every Saturday wasn't going to work. So I decided I'd do every *other* Saturday. When I sat down and started looking at the calendar, I kind of realized that *that* wasn't going to work either. So I decided that I would spend *one Saturday a month* in the darkroom. I then realized very quickly that that meant my entire year's productivity would consist of 12 days in the darkroom. I immediately concluded that 12 days a year (out of 365) in the darkroom does not a photographic career make. I realized that if photography is going to be a way of life it has to be a way of life. It's not something that you can schedule in and around the crevices of life. This idea was reconfirmed when I took a David Bayles workshop and he talked about the analogy of the violin player: that if he or she wants to keep up his or her skill with the violin, he (or she) has to play *every day*. That thought process changed the way I thought about photography. And I guess, perhaps, I need to think this way not only about photography but about podcasts—and try to do a better job of just integrating it into my life. So we'll see how I do and whether or not discipline eludes me, or whether this is an impractical schedule that I've set up for myself.

Fits and starts; they are the plague(s) of creativity.

# *The Wyoming Trip — What Worked and What Didn't*

Well, now that I'm back from Wyoming let me talk about what worked, and what didn't work, in this trip. It was a fascinating experience — the week photographing there — and I would highly recommend it to anybody who wants to photograph in Wyoming.

Here's **what *did* work:**

I had a new carbon fiber tripod which I will now swear to; these things are so lightweight and so wonderful compared to hauling around these great big heavy tripods that I've had my whole life. I was worried about the lightweight aspect of this tripod, but it worked beautifully. The few times there was a little bit of wind, all I had to do was hang my backpack on the hook at the bottom of the center column, which added a tremendous amount of weight and stability. So I'm sold on carbon fiber tripods.

I took some brand new, pea-sized Cokin graduated filters. They worked beautifully. I love graduated filters and their ability to change what gets recorded in the camera, as compared to doing simple dodging and burning in the darkroom. They're a wonderful device and I was so grateful to have those filters.

I have to put in a very enthusiastic vote of support for the individual packets of iced tea that Crystal Light makes, that you can add to a bottle of water, because they saved my bacon down there in the Wyoming desert a couple of times a day, every day. So they were marvelous.

Now that I'm back, I'm stitching images together — the first time I've really experimented with this in Photoshop — doing overlapping exposures and stitching images together to make larger images (panorama images). This is a marvelous technique.

So those are the things that I was all very happy with; they all worked, and that was wonderful.

Now, **what did *not* work** (which in some regards is even more important than what did work) was:

The Hitachi 2-gigabyte micro drive that I had in my digital camera. It did a wonderful job of recording the pictures, and I was able to review them (the last time I looked at them was waiting for my departing plane in the airport in Denver). Then, for some reason, when I got home, the micro drive was deader than a doornail. I lost 2 gigabytes' worth of images (which was about 40 or 60 images) that were gone from an absolutely wonderful day—when the clouds were spectacular and the photography was great. I was really sad to miss those images.

What's so odd about that, however, is that I've *always* come back from the field with technological disappointments: film that was scratched, dust spots, overexposed, underexposed, broken meters, out-of-focus images that I thought were in focus (particularly with the view camera). I've always had those kinds of things happen. Funny now how it is, however, that a technological failure of this kind upset me so much. I sort of feel like I wasn't supposed to have *that* kind of technological failure. But, you know, photography is a technologically-based pursuit—whether it's digital or analog, large-format or small-format—makes no difference. It's a technology-based art form; there *will be* technology failures, and I guess that's a part of the process; a lesson worth remembering, I suppose, and not allowing ourselves to get too upset about. I'll try to do my best and not be bitter. I did, however, go out and buy a whole bunch of new CompactFlash cards, and all of my micro drives with all of their little moving parts are now part of a landfill somewhere.

We live; we learn.

## PDF Publishing

We just wrapped up the production of *LensWork Extended* #67. This means we've done eleven of these, so we're becoming considerably proficient, I guess I would say, at the creation of PDF files and PDF documents for the distribution of fine art photography, and the audio and video that goes with them. And now that

I've done eleven of these *LensWork Extended*s I find m̶
a simple question: Why is it that more photographers aren̶
this medium as a means to publish their work?

A photographic book is a wonderful thing—I have nothing
against books. I love books. The printed page has advan-
tages. I know all of that stuff. But it also costs somewhere in
the neighborhood of $5 to $15—to as much as $20 each—to
produce a photographic book on the printed page. The budget
to do a typical hard-bound photography book is, at the very least
$20,000, more often $60,000 to $80,000. That is (at least in my
world) a very serious amount of money that makes books simply
out of reach for most projects (if not all projects) that I would
self-publish.

A PDF file, however, can be distributed on a CD, which costs
less than 50¢ to produce the CD, and then you have some packag-
ing, etc. Of course there is a lot of time and energy and labor to put
together a CD, and that has to be factored into a person's costs also.
But if you're doing this as a *personal* photographic project (unlike
what we're doing here in *LensWork*, where we have staff and com-
missions and all that stuff to pay) and you can donate your time
to your own personal project—then why don't more photogra-
phers self-publish using PDFs ? PDFs are a marvelous way to see
still photographs; they can be sized to full-screen and the images
look *spectacular* on the screen. Then again, it's not a printed page,
it's not a book, and it's not meant to compete with a book by any
means. But when I think of all the photographers in the world,
and all of the projects that they're working on, and every single
photographer in the world is dying to be published—I wonder
why more photographers aren't taking advantage of this wonder-
ful publishing format. In my way of thinking it is such a natural,
and I find myself a little bit surprised that I'm not inundated with
PDF publications distributed on disk by photographers who are
looking for a means and a way to get their work out there. Even if
it's only considered a first step towards eventual book publica-
tion, it's still a way to get your work out there which is very
inexpensive, very impressive, and (at least for those of us who are

y savvy) a terrific way to look at pho-
otherwise be denied us—all because
nough budget, or there is not a way to
tever. At least it's a way to get the work
involved in PDF publishing and you *are*
f you're listening to these podcasts I sort of
you ought to take a look at what's involved
s. It may be a short skill-set that you could
master in y, and find a way to get your work out to a much
broader audience than you're likely to do in any other way be-
sides a website. But with PDF you will have much, much higher
quality, and much larger images on the computer monitor. I can't
recommend it enough.

## *PDF Publishing—Some Practical Suggestions*

Yesterday a spent some time talking about PDF publication,
and wanted to expand on that just a little bit for those of you
who were maybe contemplating PDF publication, and taking it
more seriously. There are a few cautions about PDF publishing
that I thought I'd share, because I have a little experience at this
now through *LensWork Extended*. I can illustrate these two ideas
by talking about a couple of relatively new PDF-publication pho-
tography magazines, both of which I think are really interesting;
they're a good start, and I wish them all the luck in the world, be-
cause I think it's a great idea. But both have made, I think, some
rather classic mistakes that they could easily overcome.

The first is called *The Large Format Journal*. It's being pub-
lished out of the UK by a fellow named Ray Heaton. He has
a really interesting idea, and I think he'll probably be successful
with it—at least I hope so. But the comment I had to make
about his publication is that he's publishing it as essentially
8½ by 11" (a letter-size sheet), which of course is not the size
nor the orientation of a computer monitor. And so it seems like

it's an odd fit. If you're going to publish for the computer, think in terms of the computer. The publication ought to be landscape in orientation, and roughly the dimensions (or aspect ratio, I guess I should say) of a computer monitor (although that varies a little bit now with Apple's Cinema Display, but I digress). But it's not vertical, and it's not 8½ by 11".

So we have to use this new medium in ways that make sense for the new medium to be used.

The second publication that I want to mention, *MagnaChrome*, is a new publication (again a PDF-format photography magazine), and again I think it's a really great idea, and I hope they are very successful. But I noticed something in their first issue which was just posted this week or last week that I thought was kind of odd. And that is that they are publishing right- and left-hand pages in their horizontal (or landscape) orientation PDF. Well — that's a book. A book has a left page and a right page, but a PDF does not; a PDF has a single screen. It's true that you can choose a viewing option to look at right- and left-hand page combinations as if you're looking at a book on screen, but it's kind of silly to do it that way because that's not what you're looking at. You're not looking at something that, by definition of the *medium*, has a right and left page. A computer screen is one visual presentation, it's landscape in orientation, it's not facing pages like a book, it doesn't have a gutter running down the middle of the book where the binding takes place; it is a single thing, and my contention is that's the way a PDF ought to be seen. That's the publishing format for PDFs, and I would suggest if you're interested in pursuing PDF publication that you think in those terms. That is to say, think in terms of using the new medium of PDF publishing the way the new medium is intended to be used.

Back in the early days of photographic publishing, they used to put horizontal landscape-orientation pictures turned 90° in a vertical book. In order to see the landscape picture you had to turn the book physically so that you were looking at the page 90° askew, and so you could see the picture in its full

size. The thinking was in those days that they wanted to make the picture as big as possible. Well, that has fallen out of fashion, because no one wants to turn a book 90° in order to see a photograph in its proper orientation. The same kind of learning curve is taking place in PDF publishing. We're learning what this new medium is, and how it needs to be created in order to make sense. So if you're going to choose to publish your own photographic work in the PDF medium, think it through. Think through carefully what a PDF is, how it's going to be viewed by people on their computers and laptops, and take advantage of its natural strengths. Because it's *not* a book, it's not a printed page, and to treat it like a printed page is to try to make it be something that it *isn't*.

So, there are a couple of observations about PDF publishing that may be useful to you.

## *PDF Publishing — Media, Motivation, and Content*

A listener responded to my podcast on PDF publishing. They reported that they had been advised to "never bother sending out CDs to art directors or galleries. They never look at them." With this logic in hand, he suggested that my thoughts about PDF publishing and distributing on CDs were, essentially, a waste of time.

I think there's a flaw in this logic that is easily illustrated. I'll simply suggest, why do you send out postcards? Why do you send out books? Why send out any publicity material at all? Most people aren't going to read it. The theory, of course, of printed documents (like books, press releases, or postcards) is that at least people can look at them easily. They don't have to fire them up in the computer like a CD.

I've always tended to look at these things with a little different point of view. When someone doesn't look at your work, they're not making a judgement about the *medium*; they're making

a subtle — or perhaps not so subtle! — comment about the *content* you've tried to motivate them to look at. You can send out gazillions of postcards, press releases, free books, inkjet prints, etc., but if the work is not interesting, no one is going to care.

Fundamentally, I don't think the medium is either a barrier or an entry point. It is simply the carrier of the message. It's the message itself — the content that is carried by the medium — that contains all of the motivation to take action, or not take action.

Look at it this way: it's difficult for anybody to take action. It's difficult for me to look at a DVD. I have to go out and buy and install a DVD player. It requires my hard-earned bucks and a little bit of work. But I do so because the content of watching DVDs is worth the effort. I have to wear reading glasses in order to be able to read. It's a pain in the rear; I prefer not to do it. But I wear glasses so I can read because I'm more motivated by the value of the content that I'll have accessible to me via reading glasses than I am deterred by the hassle of buying, maintaining, washing every day, and keeping on my head the reading glasses so I can read. Barriers are easily overcome when the motivation is sufficient.

When the motivation is not sufficient to overcome the barrier, the resistance to view your materials is not a comment about the barrier; it's about the content of what it is that you're providing. This is Marketing 101. Why do you think advertisers put so much time and energy into trying to make commercials entertaining instead of just a boring repetition of the facts? Advertisers know that their message has to be interesting enough to capture your attention, or the content of their message will be lost. The same thing can be said about any graphic art, about any photograph, about a book, about a press release, about a postcard, about a CD that you send off in the mail. When there is resistance to exploring the medium that you've sent them, they're really telling you that they don't perceive much value in the content that you've provided them. Re-examine your content. Use their feedback as

a clue about what it is you need to do to build that audience more effectively.

## *The Importance of Archival Materials — A Woman in the Window*

For as long as I've been involved in photography (and I'm sure a lot longer than that) there has been debate about the archival properties of photographs. It's important to make sure that our images are archivally processed, that our materials are of the best quality, and that everything we do has as much longevity as is possible.

This is one of those pursuits that is a good goal for us to have. But, ultimately, we are making things that are on paper, and paper is fragile. Paper is never going to last as long as a sculpture in marble. I've always felt if you want to ensure your immortality through artwork, become a sculptor, not a photographer. Nonetheless, we all try to do the best we can with the materials available to us.

Recently, when I was interviewing Dr. Eugene Johnson for *LensWork* #67, he told a story that is so poignant and so beautifully illustrative of why we should pay such close attention to the archival properties of our materials. It explains why it is so important for us to not just ignore this or slough it off as some bit of technology that we can choose to ignore. In addition, I think this is a particularly important aspect for us to focus on now that so many people are making digital images. The whole question of archivalness in digital materials has become so important.

Rather than relate his story, I thought I'd just take this opportunity to let Dr. Johnson tell the story in his own words, from this excerpt from *LensWork Extended* #67:

"I remember taking a photograph once of a lady who used to always sit in the window. Every day I would pass her house and she would just raise her hand. She would never say a word, but she

would raise her hand. One day I decided I would go by her house and see whether I could take a photograph of her. I knocked at the door and her two sons answered. I explained. I said, "Look, I would really like to take a photograph of your mother." They said to go ahead, but to not disturb her very much because she was old. So I went around the front of the house and I chatted with her a bit. Then I proceeded to take a photograph. Interestingly enough, I promised the boys I would be back with a photograph. Keeping my word, I came back about two weeks later with a copy of the photograph. When the door was opened, I knew there was something wrong immediately. I saw it in the eyes of her sons. I dared not ask because I could already see the answer in their eyes. I asked, 'Where is your Mum?' They looked at me and said, 'Our mother, like always, she woke this morning and went to the front window and sat down. But then we heard a thump. She died right at the window.' There was an intense sadness in the room. But then the boys asked me something very interesting. They asked if I would mind if they put the photograph of their mother in the window, because that was the way they would like to remember her. And so they did. I revisited that town in Brazil almost fifteen years later, and to my surprise the photograph of the woman was still there in the window."

As photographers we never know what the ultimate destiny of our photographs will be, how long they will last, or to whom they will be important. Maybe that is the very best reason of all for us to take such care about making the best photographs that we can, putting all of our craft and skill and energy into the creation of a photograph. It is also why it is so important for us to try as best we can to make sure that our materials are the finest that we can afford and that we're processing them and preparing them so that we can ensure as long a life for those photographs and maximize the archival characteristics for those materials as we possibly can. I thank Dr. Johnson for reminding me of this in such a powerful way.

# An Appreciation of the Non-Photographic Arts

If you're like me, when you go over to a photographic buddy's house—particularly someone you haven't seen for awhile, or maybe someone who you've just recently met—one of the first things you do is start looking through their bookshelves. I like to see what are the photographic books that they own, particularly to see what they may own in terms of interesting photographic books that I don't—something that maybe I haven't seen before.

This comparison of photographic libraries, I've noticed, has gone on my entire life, with every photographer I know. When they come over my house, they do the same thing here.

However, what's even more interesting to me, when I go over to someone's house, is not to look at their collection of *photographic* books, but to look at the collection of *other* books that they own—the art books, the literature, the novels, the paperbacks, what magazines they read. I learn more about a photographer by seeing what other interests he or she has in life, outside of the direct influence of photography, than anything else.

I think I get most concerned when I find a photographer who has lots of photography books, but no other art books. How can you be a photographic fine art photographer, in particular, if you don't know anything else that's going on in the art world? If you don't look at painting? If you don't look at sculpture? If you don't look at literature, poetry, music, etc.? All of those areas of life will influence and inform your photography. There's something just a little bit too inbred, I think, for my tastes when I find a photographer has only a collection of photography books and obviously doesn't spend any time in the bookstores, or in the magazine racks, looking at any other art forms.

The obvious exception to this is music. It seems like everybody is involved in music. Everybody has a collection of CDs and some kind of stereo system. Maybe that says something about my generation more than anything else, but we all have music that we like. We all have movies that we like. So why would it be any

different with painting, with poetry, with sculpture, with fiber arts, with literature, with watercolors, with you-name-it other arts, that can be just as important for us to cultivate relative to our general appreciation of aesthetics? That's really what we're talking about, an appreciation of aesthetics. The medium of the aesthetics is, in some regards, immaterial—at least when we're talking about the appreciation point of view, as compared to the production point of view.

We photographers love photography because we love the production of photographs, but we also have a certain aesthetic that probably leaks over to other areas of art. If we don't, we ought to pursue those. I think they can be important in cultivating better photographs. There's no question in my mind that having a cultivated sense of aesthetics in non-photographic arts is a very useful and beneficial thing when we turn our photographic eyes out to the world.

## *Artificial Lighting—Where No One (At Least Me) Has Gone Before*

Since I never went to commercial photographic school, I never learned what I suspect is maybe one of the most important aspects of photography, and that is the control and manipulation of artificial light to illuminate a scene. I've never done still lifes. I've never done commercial work of any kind, advertising photography, etc. My primary interest was always in landscape and working out in nature.

However, now that I'm doing some video recording for the *LensWork Extended* series, I've had to learn about artificial lights. I've begun to study the application of artificial light to illuminate a video scene. One of the things that's been most interesting is to simply take that observation and turn it towards the experts at doing artificial lighting—Hollywood. They understand lighting so incredibly well.

I've become an absolutely addicted fan of the television series

*24*, and have been watching that entire series on DVD. I have to admit that I find myself riveted by the plot, but every once in while I'm able to break away for a few moments to just examine the lighting that they use in filming that television show. It's absolutely spectacular. Everything from color, and direction, and the number of lights, and the use of key lights, back lights, drop lights, you name it. It's absolutely fantastic, and something that has got me so intrigued that, for the first time in my life, I am actually seriously contemplating doing some still life photographs, simply because I'm kind of anxious to go play with lights and lighting, and to see what can be done when controlled in an artificial lighting scenario.

Now if I can just find an artificial light source that has the equivalent of the sun so that I can specifically illuminate my landscapes, I think I'll be one heck of a happy camper. Pending that purchase, I guess in the landscape, I'll just continue to be patient. In the studio, however, I am very excited to try using some of the hot lights that we have purchased for our video production to see what I can do to photograph some still lifes. It could be very fun indeed.

## *National Fine Art Photography Day*

I'll bet you didn't know that last October 15 was Poetry Day in the state of Maine. It's a state commemorative day for them to celebrate the life of poets who have contributed to the culture of Maine and, I guess, the poetry scene there.

I don't mean to be disparaging, but I feel a little slighted. I think we need to have a National Fine Art Photography Day: a day when the entire nation—including a Presidential proclamation, I suspect—could celebrate fine art photography. I can think of no better vision than to lobby that National Fine Art Photography Day should be the day after Thanksgiving, which in some circles is known as Black Friday, because it's the largest shopping day of the year—of course, we would all assume

it would be appropriately renamed Zone Zero Friday, which I think is appropriate for fine art photography. We could also use it is a day when all of us who are fine art photographers could give away photographs as gifts; we could sell them as potential Christmas presents, etc. Nothing could be more appropriate for National Fine Art Photography Day than, I think, a day of badly needed commerce for all of us. What do you think?

So, what I need to know is who we write letters to in order to promote National Fine Art Photography Day? Should we just all pack up our cameras and head out there into the world and make photographs on National Fine Art Photography Day? Do we even have to have it be an *official* thing for there to be a National Fine Art Photography Day?

Can we just decide we want to make one ourselves? In which case...By The Power Vested In Me—by no one in particular—I am hereby declaring the day after Thanksgiving as National Fine Art Photography Day. Go forth and do fine art photography.

Hey, if they can have a Poetry Day, why not us?

## *A New History of Photography*

A while back I was bemoaning the fact that there was no decent photographic history of fine art photography since about 1950. Beaumont Newhall's great photographic history doesn't really cover modern times. Even Naomi Rosenblum's *The World History of Photography*, which was largely based on Beaumont Newhall's work, doesn't cover contemporary photography very well.

This has always been a little bit bothersome to me because I think about the amount of fine art photography—particularly fine art photography publishing—that has taken place since just, say, 1975—it's a nice convenient line of demarcation. It seems like we should have a better history of photography since then.

Well, in response to that podcast, a number people

recommended a book called *A New History of Photography*, origi-
nally published in French, edited by a guy named Michel Frizot.
I don't speak French and so I hope I'm not ruining his name.
It's a really terrific book. I finally found a copy. It's not currently in
print, but still available through Amazon.com or abebooks.com.
I would highly recommend this book. It's almost 800 pages,
very liberally illustrated with photographs and scholarly essays.
It's a really terrific resource on the history of photography. I have
a suspicion it will easily become a replacement, in my world any-
way, for Beaumont Newhall's *History of Photography*, and even
for Naomi Rosenblum's more recent *The World History of Photog-
raphy*. This particular book is, I think, a fantastic resource, and,
if any of you are students of the history of photography, very
definitely one I think is worth picking up and having in your
library. So there you go. My request for information was fulfilled
by podcast listeners and I appreciate the advice. Thanks so much.

## *The Value of Your Photographic Library*

In the world of fine art photography prices, values have been
escalating now consistently for, well, about 40 years. What pho-
tographs sell for today would have been undreamt of in the late
1960s or early 1970s. Photography has become quite an invest-
ment, and a collectible. Many of us have some photographs that
have escalated in value, and we tend to think of them as some-
thing we should take care, store carefully, protect in a safe deposit
box, because these are valuable pieces of artwork whose prices
are escalating.

However—and this is the strangest thing to contem-
plate—the most valuable aspect of the photography that
I personally own is not at all the *photographs* that I own—certainty
not mine. The real value in my so-called photographic collection
is in the *books* that I own. Most of us who are involved in pho-
tography buy photography books, have a library of photography
books. Have you taken the time to look at what your photography

books are currently worth? It is absolutely mind-boggling how books have escalated in value.

For example, my copy of *The North American Cowboy*, by Jay Dusard, which was relatively unimportant but a very good photographic book when it came out in the 1970s, cost $40, something like that, brand new, retail. Now I see it regularly listed for anywhere from $600 to $900. As a collectible investment, that book is worth a lot more, and in terms of an increase in value, that is to say appreciation in the investment, it's mind-boggling! I own all four volumes of the Museum of Modern Art's series on Eugene Atgét, which has escalated to a tremendous value.

I got very concerned about all of this a number of years ago because it suddenly dawned on me that no one in my family would know what these books were worth, what the value is. In order to track them for the future, for a possible appraisal, for escalation in value and appreciation, let alone for my eventual estate sale, let alone potential insurance claims, etc., I decided I needed to take an inventory of these things and start keeping track and monitoring the current value of my collectible photography books. This includes most of the photography books that I own, quite honestly—not that I've selected ones that are collectible, it's just that almost all photography books have, with the passage of time, become collectible.

To solve the problem of gathering and keeping all this data, I went on a search several years ago for a piece of software that would allow me to do this. I want to recommend that piece of software here for those of you who are interested in the organizing and capturing the value of your photographic book collection. It's a little piece of software called BookCAT. It's by FNPRG, which I have no idea what that stands for, but that's their website, too, FNPRG.com. Look for a product called BookCAT. This has the unique ability to keep an entire library database on your computer. It is easily backed up, so you can store a copy of your data in your safe-deposit box. It will capture the information of all the books you own by your simply typing in the ISBN numbers. It then goes online and looks up that ISBN number in a database

somewhere out there in the world, and downloads the entire information about your book — the title and all of that — so that you don't have to type any of that in. It also has a database field where you can enter important financial information about your books — how much you paid for them, when you bought them, what their current value is, what the date of that current value is, etc. It doesn't have the ability to find the current value for you. You'll have to do that by looking up the books that you think have value, either on Amazon, or abebooks.com, or Andy Cahan, or those kinds of places. Keep your eye out on auction sites, etc. You have to manually capture current values, but it does give you a place to keep them, and organize them, and track them, and to run reports on the value of your collection, and the most recent data of those values, as well as where you found proof that your books are worth a certain value. This is all very important information to capture for something that has escalating value.

Another little side feature is that it has the ability to maintain essentially a lending library database, so that if you loan your books out, people can sort of check them out. You can keep track of who has which of your books, and when they're due back, so that you can keep track of them. It's useful for small libraries, church libraries, that kind of thing. That's who they advertise this for. It's not a bad feature to have anyway. It's a very inexpensive piece of software and does a really terrific job of keeping track of all this information. I think that when you run the report, after you've filled out all the information, of what your current photographic library is worth, you will be amazed, surprised, stunned, and very glad that you're capturing this information for everything from insurance purposes to future valuations. That's it, BookCAT by FNPRG.com.

## *A World of Photography, Literally*

I'm frequently amazed at how provincial photography is, how regionally defined it is.

I live on the West Coast of the United States and, of course, I'm heavily influenced by the West Coast School of Photography — all those great landscape photographers from the Carmel area, the *f*/64 group, etc. But photography is much, much, much bigger than my little corner of the world, which goes without saying, of course. I am still amazed how here we are in the 21st century, and still there are these provincial little clusters of photography that are relatively insulated from one another. This shouldn't be the case here in the age of the Internet and international publication, etc., but it's true.

This really came home to me when I was preparing the content for *LensWork* #67 because we received a portfolio which we're publishing from a fellow from Norway, a portfolio of portraits from a fellow who lives in Oman, and a portfolio from a fellow who was born and raised in Turkey. We sort of internally refer to this, by the way, as our international issue, so to speak, because by sheer coincidence we have all of these non–U.S.-based photographers. We enjoy that, but it got me thinking how provincial photography is, because I cannot, for the life of me, tell you a photographer that I've ever heard of from, say, India (which has a billion people), and very few photographers from China (which has, like, a billion people). The planet is huge. There have got to be photographers in these various areas of the world, yet whoever is doing great work in China is probably getting an audience in China, but not much in the United States. I suspect there is some of that in the other direction, that it's very difficult for an American photographer to get an audience in South America, or the subcontinent, or even Europe.

It's too bad. Of all of the arts, photography seems to me to be *the* most democratic, the most universal. It requires no language skills whatsoever, and is absolutely graspable, regardless of the culture that you're from. Even if the subtleties contained in a photograph might escape you because you don't get the subtleties of context, the core of the photograph is pretty understandable regardless of the time, the culture, the location, etc. Isn't it too bad that photography, even to this day, remains as

provincial is it is? Wouldn't it be a wonderful thing if there were more interchange of fine art photographs amongst all the peoples of the world? I for one would applaud that and support it. In fact, we are doing the best we can in *LensWork*. We'd sure love to see more international submissions, just to see what's going on out there in the world that is pretty invisible to those of us here in America, who are very likely unaware of the wonderful work being done all around the world.

## *Sequencing, Meaning, and Comprehensibility*

It's obvious, I suspect — well, at least I hope it's obvious — that a random collection of words, or a random sequencing of paragraphs from a novel would make meaningless communication. Said another way, the *meaning* in communication is a function of the *organization* of the medium. So, the proper sequence of words communicates effectively, the proper sequence of paragraphs tells a story, the proper sequence of chapters lays out a novel.

Exactly the same thing takes place in photography. At least, this is one of the things we've discovered in doing *LensWork*. We can significantly change the way a group of photographs is perceived, or understood, or comprehensible, by rearranging the sequence of the photographs. So an incredibly important part of our process in putting together a portfolio for *LensWork* or *LensWork Extended* is to pay very careful attention to the sequencing. In the magazine in particular, we look very carefully at the right- and left-hand page combinations.

I'd like to propose a project — experimental, albeit, but a project nonetheless. Take a group of your images that consists of a reasonable number — 10, 20, 30 images, something like that. Print out some, maybe, cheap LaserJet copies, or something that you can put on the floor and they won't get boogered up. Rearrange them, looking carefully at right-left patterns, at the sequence of images, and how one image plays into the next,

plays off the next, balances or counterbalances, or does *not* balance with a pairing, whether it's right-and-left, or left-and-right. Look at the sequence of images and see how the sequencing changes the meaning and the comprehensibility of the photographs.

It won't change the core. I mean, pictures of poverty in Peru will still be pictures of poverty in Peru, just like the rearranging of paragraphs in a Dickens novel are still going to be Dickens-composed paragraphs. But it *will* change how easy, or how difficult, it is to comprehend the overall package. That's the important part of the sequencing. It makes it easier for the audience to "get into" what it is that you're attempting to produce, and to comprehend more easily what it is that your photographs are attempting to communicate.

## *Graphic Layout and Design Skills*

The element of design in photography is typically limited to ideas about composition and the rule of thirds; for all intents and purposes, it's limited to how we arrange the objects in the three-dimensional world to appear inside the square or rectangle of our two-dimensional photograph.

I'd like to propose that design is a much bigger topic than this, particularly in this day and age in which so many photographers are involved in other elements of design that contribute to the final product. For example, in the final presentation of photographs for the last 50 or 75 years, an element of design has been how the photograph is presented to the public — that is to say, in the white matte board with the over-cut, beveled window. That is, actually, an element of design. It's a very simple, very elegant, very effective design, but that's only a minor part of what design is for today's photographers.

So many of us carry our photography beyond the mere *photographing* process. For example, there are such elements as: How do you design the page of the layout of the book? How do

you design a portfolio? How do you design some other kind of presentation, like to folios that I do? When I'm doing work that involves image and text (which I found myself doing more and more these days), all of a sudden design elements include typography, sheet layout, colors, the design elements of my folio enclosures—all of those elements of design become a critically important influencing impact on the final presentation of the photographs.

I think where photographers used to spend all of their design education, if you will, focusing on the idea of composition *inside* a photograph, I suspect that now we need to expand that horizon a little bit. We need to start paying more attention to some of the larger areas of design and learning a bit of background in graphic design and the whole world of graphic layout and presentation. It's a skill set that we photographers should definitely pay more attention to.

## Creating in the Midst of Everyday Life

I'd like you to hear some advice from a fellow photographer and my friend Chris Anderson.

CA: "I had photographed in the landscape and obviously the sky is part of that, for the last 23 years, or 30 years now, and at some point I started just looking up at the sky and seeing what were to me interesting and fascinating cloud formations and occasionally made a photograph. It was always spontaneous because it wasn't something you can plan for. You couldn't take a week off and go photograph clouds because there may or may not be any that week and so during my normal work day I would occasionally see something that was interesting. I do a lot of outdoor portraiture and I would photograph it and this went on for several years and it sort of slowly became this body of work that I was hesitant to show to my photographer friends. Not commercial photographers, but to my artist friends."

BJ: "Because you thought maybe they wouldn't appreciate it or because they perceived you as a commercial photographer?"

CA: "No, because clouds were a subject matter that Stieglitz dealt with in the 19-teens and '20s..."The Equivalents..." and then I initially was hesitant because they kidded me about it and said *this has been done Chris, one of the greatest photographers of all time did this a century ago* and I just kept at it, and eventually they were interested to see what was new, what was next. I have literally exposed thousands of negatives and made hundreds of prints of these clouds and pretty soon they began to accept and they've sort of embraced this whole project and when we would have conversations it would be *What's new? Let's see your new cloud photograph* and they sort of took on a life of their own."

BJ: "Yeah, one of the fascinating things about what you're describing that you did, to me, is that you didn't have to make a project out of it because you didn't have time. You're in the middle of your busy workday, you're photographing a portrait literally in your backyard where I know you do a lot of outdoor portraits, and you'd simply look up and there's a cloud and you'd photograph it. It's at hand, you don't have to travel..."

CA: "Exactly! And it's there and it's fleeting and some of these last for 15 seconds and then they would have moved on to a spot in the sky that was either blocked by a tree or the angle of the sun was different or something and a very ephemeral kind of a subject matter that required instant recognition and a great deal of spontaneity that wasn't part of my personal work before. As it grew I always had a separate camera that was dedicated to this, to the clouds, and it had a red filter on the lens at all times and was always there loaded with black and white film, and if I saw something I liked I'd pick up that camera and photograph it. There's one spot that gives me a fairly clear view of a good portion of the sky and that's where I stand, and as the years have gone by I have the camera with me and I'll drive to the store, the grocery store, and I'll have the camera with me and just pick it up and grab something if I see it. I remember standing in the parking lot of REI here in Portland and the sky was fabulous and I'm standing

out there pointing my camera in the sky wondering if the other people that are coming and going are wondering what this strange guy's doing out here and it's funny, after it appeared in *LensWork*, of course I showed it to my friends and photograper friends, and there have been a couple of occasions now that my phone has rung at six o'clock on a Sunday morning and it's one of my photographer friends saying *you've got to go out and look at the sky!* and you know I'm sound asleep and so I wander outside and look up. The other day this happened and sure enough it was fabulous and I had to load the camera and get out there and photograph and I couldn't go back to sleep after that."

I'm so glad that Chris had this experience — learned this lesson about photographing in his everyday life and shared this with me during this interview, recorded in the spring of 2003, about the same time we published his *Clouds* portfolio in *LensWork* #45. Chris died on October 29th of pancreatic cancer and I attended his memorial service this last weekend. Because he was a friend and because he was a fine photographer, I doubt I will ever look at clouds again and not remember his work, his wisdom, and his friendship.

## Used Equipment and the Changing of the Guard

It's fairly true in life that, as the old maxim says, someone's joy is someone else's lament, and of course vice versa.

I was reminded of this just earlier this week when by sheer coincidence I happened to run across a Calumet Cambo 4x5 view camera that had sold on eBay. Nice-looking camera, in pretty good shape, a 4x5 monorail camera with two lens boards — sold for $99. Now that's bad enough, that you can buy a 4x5 view camera in this day and age of for $99, but the insult-to-injury part of the observation was that it sold after *12 bids*. The opening bid on this 4x5 camera was $5.39! Now, it wasn't that long ago when a view camera and lenses and the accessories that it

required to be able to do that kind of photography was for all intents and purposes beyond my reach. As a young photographer I lusted after such equipment. Now in this day of easy equipment accessibility, eBay, the Internet, of course digital photography, such wonderful pieces of equipment are available basically for the asking—which reminds me of all the darkroom equipment I have downstairs, sitting by idly, and the number of photographers I've had tell me essentially the same thing. It is a sign of the times, no doubt about it, but it is also very much for me a sort of emotionally sad sign of the times, to see such wonderful equipment sit idle and to be essentially so insulted on the auction block. It's too bad, but I suppose it's no different than the way a previous generation of photographers felt about their Ellwood wooden enlargers and their Kodak Ektar lenses, parmelian paper, coda-bromide paper, and all the other wonderful equipment of yesteryear that is no longer available. Such is life, and I suppose we'd better get used to the idea that time marches forward and has always done so.

## *Photographing the Wind*

Well, this morning we're in the midst of a pretty good-sized windstorm, a big winter storm blowing through here in Anacortes, and big whitecaps out on the water outside my window, and when you have a big windstorm like this of course you're thinking of wind, which in my brain always interfaces with photography in some way or another, and it occurred to me how few are the photographs I've seen that have visible wind in them. There are some, of course. I think of *Fleeing A Dust Storm* by Arthur Rothstein—that's a classic example of a photograph with the visible effects of wind shaping the subject matter—but there are few others, at least not that I can think of off the top of my head. Maybe *The Flag Being Raised Over Iwo Jima.* There's probably more that I just can't remember at the moment, but flipping through real quickly a history of photography book,

I couldn't find another photograph that had visible wind in it...
and I wonder why that is? We see clouds all the time. We see
storms, we see, you know, crashing ocean waves, that kind of
thing, but wind shows up so rarely in photographs, and I can't
help but wonder if it's because windy conditions are so dif-
ficult to photograph in. It's hard to have a camera on a tripod
in a windy condition and make a photograph where the wind
shows, because everything else gets blurry too as an effect of
the camera vibrations — that is to say, the content of the pho-
tograph is dictated at the convenience and physical comfort of
the photographer. I suppose that's no different than any other art
form, but it is true and it is limiting and of course always loving
a photographic challenge, it makes me want to get my camera out
there this morning and see if I can photograph the wind.

## *The Multi-Talented Artist*

My assistant Holly is a very talented videographer and graph-
ic designer and computer-savvy individual. She's the one who
prepares all of these podcasts for broadcast and there is no doubt
she'll be considerably embarrassed by the content of this particu-
lar podcast. Sorry, Holly, but an interesting thing about Holly is
that she is also a talented pianist and a painter and she's a very
good cook and her talents otherwise are multi-ranging, and that
got me thinking about the photographer friends that I know
and the various photographers I've interviewed for *LensWork* over
the years and thinking about the multiplicity of talents that they
have, and as painful as it was, I had to conclude that most of
the photographers I know are creatively talented pretty much in
photography and that's it. There aren't a lot of photographers that
I know who are talented across the board, with one single excep-
tion: musicians.

Pianists who are photographers are legendary. Ansel Adams,
Paul Caponigro, the list goes on and on, but I don't know any
photographers who are also painters. Maybe Charles Sheeler or

David Hockney, but I don't know them personally. I don't know any photographers who are also sculptors or writers, at least very few. Maybe Wright Morris comes to mind—a photographer and a novelist—but that sort of interdisciplinary tendency that I see so often in other art forms is not nearly so present in the art form of photography. I wonder if that's because photography is so technically demanding that it's difficult to master photography and other art forms too, or is it that photography lends itself to a certain kind of creative mind that sees in just this one medium alone? Of course another possibility is that I just don't happen to know or happen to have contact with photographers who are talented in lots of other mediums and have lots of other ways of expressing their creativity. It is curious, and it does give me pause to think about photographers and their approach to creativity and how it's maybe perhaps a little different than other types of creative artists.

## *Preservation*

From time to time in these podcasts I like to just sort of randomly talk about something that comes across my mind that I quite honestly haven't thoroughly thought through, so I reserve the right in this particular podcast to change my mind and to offer a future podcast that completely refutes what I'm about to propose here. Thus is the joy of the process of learning and growing as we age. So, throwing caution to the wind, let me proceed.

In this age of digital photography, particularly relative to digital storage of images or the digital distribution of images, a lot of people complain that digitally stored images or digital distribution like we use with our PDF publications can go out of date and they will no longer be visible at some point down the road, and that's a reason not to publish digitally or to publish in PDF and in particular why books are a preferred form of publication...but have you ever wandered around in a used bookstore and looked at the old photography books there? How many of

them now appear so badly printed that your interest in buying that book and spending time with it almost evaporates because the printing quality is so bad or the bindings are falling apart or the spines are broken or there is water damage or missing pages or yellowing pages because the materials they used to produce the book were not archival or there are dog-chewings or soiled pages or bent corners or missing dust jackets? I mean, just because something is in a book doesn't guarantee that it's going to have longevity.

A good friend of mine was complaining just the other day that, unfortunately, in the room in which he stores his photography books there's been some inconsistent heating, the result of which is that most of his photography books have started to mildew, and they smell, and he's got mold problems, and etc. Book publishing is no guarantee of longevity any more than publishing in PDF on a CD is. What counts is when someone cares enough about a project, about a book, about a photograph to preserve it and it's the act of preservation that is more important than the choice of medium.

## *The Universal Itinerate Photographer Fantasy*

In my youth, that is to say, more specifically, in my late '20s and early '30s I had a fantasy for a while, a photographic fantasy, that I would sell all of my belongings, liquidate out of modern life, as it were, take all proceeds, buy a camper and pickup, convert it into a darkroom and a small conservative living space, and head out on the American Highway and spend my time full-time as a photographer of the landscape and small-town America, and do all the film developing in my camper on the road—being, essentially, an itinerant fine art photographer living wherever my camper happened to be parked. I went so far with this fantasy as to actually do all kinds of spreadsheets, a cost analysis of miles driven, the price of gas, wear and tear on the pickup, how

much cash I could generate if I liquidated everything in my life and focus my energies on this particular thing. For a long time I seriously considered this, and sort of thought it a fantasy life that I would really enjoy living.

Well, curiously enough, as I started slowly, tentatively talking about such plans with some friends of mine, and in particular some older photographers, I found out that this is an almost universal fantasy. Almost all fine art photographers—at least the large-format photographers in the western landscape—have dreamt of such freedom to go out and photograph, and a few actually have done it. I think a sort of a variation on the theme is Michael A. Smith and Paula Chamlee and their fire truck driving all over the country. These fantasies about being free to pursue one's artwork are such a seductive temptation. It would be a lovely thing to be able to do, but the more I played around with this fantasy idea, the more I discovered that although many of us contemplated such a radical change in lifestyle and such a free approach to creating artwork, we all found that the realities of making a living and financing such a venture were substantial, and I can't help but believe that artists throughout history have been tempted by the same idea in its many variations, and all of us have found that the pragmatics of being an artmaker are that you also have to be engaged in society and in life and in the day-to-day affairs that all the non-artmakers in our society are engaged in. The challenge of being an artmaker is not the challenge of configuring your life for escape; the challenge is configuring your life so that it can include the everyday affairs of everyday life and the time, the discipline, and the necessities of being an artist.

# Benny Goodman's Creative Dead-End

Those of you who have been followers of the podcast for a while know of my passion for big band music, and in the world of big band music there were few big band leaders who were

bigger or more famous or more influential than Benny Goodman, who was affectionately known as the King of Swing. He was at the top of his game, defining the big band era, in the late '30s and through the mid-'40s. But by 1945 or so, the big band era was coming to a close as the war years ended, and Benny Goodman's popularity — that is to say, the business of big band music, concerts, record sales, etc. — was starting to wane, partly because of that and partly because of a musicians' strike. A lot of the big bands simply disbanded. They just couldn't survive from a business level — couldn't make payroll, etc. — so they disappeared. Some, like Benny Goodman, tried their best to hang on, but recognizing that they simply weren't going to be able to succeed as big-band bands, decided — I should say he decided — to change the direction and focus of his big band and try to follow the public trends. Now in the late '40s and through the early '50s, the musical trend that was growing out of the big band era, and partly out of jazz, was bebop, led by people like Dizzy Gillespie and Thelonious Monk and even a young Miles Davis, and Benny Goodman decided he would try as best he could to follow the bebop trend, primarily in an attempt to secure an audience and keep his big band alive. So some recordings of Benny Goodman's big band from the late '40s, starting from about 1945, take on a very bebop kind of sound. Well, that's not what Benny Goodman was. He personally didn't particularly like bebop music all that much, but he felt it was necessary to try to be a bebop band simply to follow the popular whim. What's interesting about that is he didn't succeed at that either, and eventually went back to playing big band music — later, when it almost became sort of nostalgic to be a big-band band. In essence, he sort of wasted some time trying to be something that he wasn't — to pursue something that was popular but not true to his musical roots and true to his musical passion, and I think there's an obvious parallel here for us photographers.

Fashions and trends in the art world in photography change just like they do in music. For a while a certain style of photography will be popular and then for awhile something else will be

popular, and these fashion shifts of the wind, as it were, can take place over the course of years or sometimes decades, but I think what counts for those of us who are trying to be creative artists is to find what's true to our heart even if what is true to our heart is outside the fashion trends of our times. But what Benny Goodman did by pursuing bebop—music that was not true to his heart—was to make essentially bad music. It was bad big band music and it was bad bebop music, and Benny Goodman, in retrospect anyway, was much better being Benny Goodman than he was being anybody else. By the same token, those of us who are trying to be creative in photographic arts will do a much better job of trying to be true to ourselves even if that pursuit puts us completely out of step with the contemporary fashions or the contemporary trends that surround us. These things do change with time. Being true to your heart is the only way to make really interesting and significant artwork, even if it will take a generation maybe to discover that that work is in fact interesting and significant because at least the way I tend to think about it, there is almost no correlation between popularity and creativity—that instead, the important correlation is between creativity and passion...a theme which I know I sometimes seem to beat to death in these podcasts, but here was another example of Benny Goodman I thought I could use to illustrate the point. Be true to yourself. Make your artwork and, albeit perhaps in the long run, what you produce will be much more significant and much more interesting.

## *The Niche That Is Photography*

Well, it's that time of year when we all start thinking about Christmas gifts and the holiday season that is fast approaching, and for some reason this got me thinking about the photography that I create and how I tend not to use it as gifts. I tend not to give away my photographs to my family members and etc., and I wondered why? And then it dawned on me that I don't

think my family would care to receive any of my photographs. You know photography is this incredible niche thing—you're either sort of into photography, as it were, or you're not—the same way some people are into golf or into fishing or into camping or into any other hobby or art form or pursuit in life. Photography for us (for you, I suspect, if you're listening to this podcast) is a very important thing. It's a part of our passion. It's a part of who we are. It's a part of how we relate to the world, how we define ourselves, how we interpret our life, and photography for us might be a perfectly appropriate gift, but I can't imagine giving my aunt Etna a portfolio of my photographs and having her appreciate it as artwork. She might appreciate it because it came from her nephew or something like that, but I mean as an art object or as a Christmas gift, it's not likely to rank up there with a new Cuisinart or something, you know?

This has always been one of the things that has bugged me about photography the most: other photographers appreciate photography, but people outside the world of photography tend to think of it as something that is perfectly ignorable. It is not a part of their life. It is not a part of their interest, and they can just pretend like it doesn't even exist. I have friends who could care less about professional sports. They don't understand my passion for baseball. Other friends of mine think that my total disregard for the theater is just bizarre because they live, eat, and breathe the theater. We live in a world in which we are all separated by our various niche interests, and those niche interests tend not to cross-pollinate too much, at least in consumer society. Photography—well, specifically art photography—has been relegated to a tiny, tiny niche of people who really love the graphic image, and I suspect it's likely to be that way for a long time, so I better get used to it, don my coat, and head to the shopping mall where I can buy my Christmas gifts rather than make them, and I suppose with that comment you may now refer to me as Scrooge.

# *How Much Detail Do You Need?*

I've been recently following a discussion on one of the chat groups on the Internet about the preservation of detail in a photograph and how it is that we can employ digital techniques or sharpening or certain kinds of printer inks or which RIP does a better job or which film has higher   on about the preservation of the maximum amount of detail. Now, that's intellectually interesting, and I think we should push our materials as far and as hard as we can push them. We should know what they can and cannot do. We should know the limitations of our materials, and there are some images in which maximum detail might be an important aspect of the image. There are others, I suspect, where this kind of pursuit becomes a distraction from seeing and thinking and feeling creatively. Not every picture needs to be tack-sharp. Not every picture needs to have smooth tones. Not every picture needs to be absolutely grainless...that in fact, what is important is not detail in the image, but detail in the sentiment.

I guess I'm sort of paraphrasing the old Ansel Adams advice that there's nothing quite as sad as a sharp photograph of a fuzzy concept. Nowhere, I think, have I heard this expressed quite so succinctly as in the following snippet from an interview I did with California photographer Larry Wiese via telephone, for a *LensWork* multimedia program back in 1998. Larry is a terrific photographer. We've posted this as an audio clip on our website before, so some of you maybe have heard this, but if you haven't, it's well worth sharing again, because it's wisdom worth remembering.

"It's interesting, I have a very close friend [to whom] I was showing work one evening, and this individual looked at one of my images and he said *Well I really like the image. It's got a good feel to it* he said *but you know, I really wish I could see more detail in the tree.* And you know I'm not overly quick on my feet, but this night I was, for some reason. I said, *well, you know it's a tree, don't you?* and he said *well yeah* and I said *then why do you need any more detail? If you know it's a tree, what else do you need? That's not*

*the primary subject matter of the image anyway* and it was interesting because I wasn't really jumping on him because he's a close friend, but for both of us I think there was a revelation there. I thought *aha!* and he looked at me like *gee I never thought of that before.*"

## Motivations Versus Mechanics

Through my work with both *LensWork* and *LensWork Extended* I've had an opportunity to interview an awful lot of photographers, and one of the things I see somewhat consistently is how the pace of the interview changes the minute we stray into a technical discussion. I'll typically avoid technical discussions when I interview photographers, because that's not the purpose and objective of *LensWork*. We tend to focus on photography and the creative process, as most of you probably well know, but from time to time I find that a very difficult topic to interview people about, because they're not particularly consciously aware of their creative motivations or their process or other aspects of the non-technical parts of their photography that they can talk about them, but the minute I say *well, you know, what camera do you use?* the conversation quickens. Their responses become even a bit excited sometimes, and I'll get this lengthy description of what equipment they used and how they used it and some of the technical problems that they had to overcome. My saying so is not at all any sort of an indictment of photographers, but rather an observation about human nature—that the reasons *why* we create are a lot more difficult to plumb than are the reasons *how* we create—but I've always felt that in artmaking, why we make something is much more important, and much more of interest, than how we did it. *How* is mere technology. Not that I can slough it off so easily that it's inconsequential, because it obviously is, but the *how* of creation to me just seems to be a completely different order of thing and not nearly as important—ultimately, anyway—as the *why* we photograph

and the rationale and motivations behind our creative impulses. Besides, for the vast majority of the audience whom we hope to develop, who are not themselves photographers, how we created something is likely to be significantly less of interest to them than is why we created it and what we're saying with our artwork, and I suppose the proof here is that I have absolutely no idea what kind of guitar Eric Clapton uses, but that does not in the least prevent me from being captivated by the music that he creates. I don't know the materials of paint or brushes that Rembrandt used, but I could look at his paintings for hours. I have no idea how Mark Twain wrote *Huckleberry Finn*, but it's one of my favorite books. My suspicion is that the how a piece of artwork is produced is only of contemporary interest and will quickly be forgotten if the artwork survives because it actually has something interesting to say.

## Some Old Contact Sheets

I am engaged in a stupid and somewhat mind-numbing little organizational project. I'm scanning all of my old contact sheets from my film files so that I can have low-res scans of those available on my computer and can look more quickly and more easily at contact sheets from (particularly older) work. In the process of doing these scans, I'm kind of amazed at the fresh eyes with which I find myself looking at some of these old negatives that go back in some cases to the '70s and '80s but particularly the early '90s. This stuff is 15 years old now, and a lot of things I photographed sort of on a whim, you know, take a picture, worry about it later. They weren't really part of a project. They weren't part of anything that I was doing at the time but something obviously must have caught my eye so I made the image. Well here I am, 15 to 25, 30 years later looking at these contact sheets and saying *hmmm*, will you look at that! That could be very interesting. So in the course of doing what I thought was just a stupid little

organizational project, I have come up with at least a half dozen potential projects of things that would explore ideas that were only briefly glimpsed much, much earlier in my career.

When I mentioned this to one of my photographic friends the other day he said *oh yeah! I do that all the time. I go back through my old contact sheets on a fairly regular basis just to see what I was seeing back then before I was conscious of seeing it.* I thought that was a great phrase, and my suspicion is, it's probably a bit of a universal truth that a lot of times we see things before we are conscious that we are seeing them. Not a bad reason at all to spend a little time with those old contact sheets.

## *Art History and Art Movements*

There's a lot to learn about photography and about the world of fine art by studying art history, and I've been an advocate for a long time of studying art history as photographers, but one of the things that fascinates me about virtually all art history books, with only a few exceptions that I can think of, is they tend to be the history of artistic movements, and the thinking tends to be linear in time and reactionary—that is to say, such-and-so style of painting was a reaction against the previously dominant style of painting. Impressionism was a reaction against the almost-photorealism that was so popular in the salons of France, etc. Or, in photography, the photo secessionist movement, with fuzzy pictures of mythological tableaux, if you will, was a reaction to some of the stark documentary and portraiture of the daguerreotypes and the early photographers, and subsequently *f*/64 group and all of that was a reaction to the photo secessionists. Robert Frank and Lee Friedlander and Gary Winogrand were a reaction against the clean, pure landscapes of the Ansel Adams school.

That kind of thinking is very very prevalent. However, I tend to think that that's not the way artists make art. We don't make art as a reaction against something that is dominant. We are just exploring ideas, exploring ways of seeing, exploring ways of

expressing ourselves, and then it's the historians who come later and apply all this kind of armchair quarterbacking and rationalization to the trends and movements in a particular a style of artmaking, and I think one of the ways to sort of illustrate this point is that in all times, in almost all places, there are almost all styles being done at once. Here in my little town of Anacortes, Washington we have quite a number of very talented painters, and they all have little galleries and they're making a living selling paintings and they're doing some awfully fine work, and in amongst those painters you will find abstractionists, you will find Impressionists, you will find very straight photo-realist painters, and every conceivable variation therein. None of these painters are ever likely to find their way into art history books, because they're not the first to do something, and that tends to be the focus of all art history writing and scholarship: who was the first person to do something. But again, I don't think that's the way we create when we create artwork. We don't do things in order to be the first so that we can cement our place in history. Probably some people do, but most of us who are creating art tend to think in terms of what is the best way for us to make our creative statement and to explore the artistic vision that we have within us — that is to say, the creative act comes first, and the art history comes subsequent to that, as a sort of analysis of what we've done.

One of the things that is so fascinating about art is it doesn't really take place linearly through time — even though it tends to be presented that way by the art historians — but rather that it happens all places at once, that is to say, I can equally take my inspiration from the primitive cave paintings at Lascaux and the sophisticated ukiyo-e woodblock prints of 19th-century Japan and African masks. From all places and throughout all kinds of history there are all kinds of expression, and that's the true nature of how art evolves, not in this linear progression of movements. Now having said that, there is another thing that is fascinating to me, and that is, who is it that gets mentioned

in these histories of art? They tend to be the people who start-
ed the movements. So Lee Friedlander becomes an important
photographer in the history of art because he sort of invented
a style of photography, if you will, that was intending to say
something with his particular point of view, and the same can be
said working back in history about the *f*/64 group or Stieglitz or
P.H. Emerson, etc.

It's interesting to note that although right now we find ourselves
in the modernist and postmodernist phase of art and photogra-
phy, in reality the kind of photography that is actually being
done across the planet is all kinds of photography. There are
daguerreotypists right now doing portraits...Robb Kendrick
and his cowboy tintypes come to mind...there are people doing
photography that is very much in the West Coast tradition, in
the Magnum tradition, in the new traditions of Lewis Baltz
and Robert Adams, etc. All of photography takes place all
the time, and so the history of photography—which tends to
be a linear movement, a linear progression of styles marching
towards...well, we don't know towards what, but towards some-
thing—is a bit of an artifice, and once again we find ourselves
back at the same conclusion, that as artmakers it's not the history
of art that should determine our direction, but rather our own
creative spirit and our own creative voice that should do that.
The lessons of the history of art are simply springboards for in-
spiration, and in that sense they're well worth studying, but not
at all in the sense—at least in my way of thinking—that they
create sort of an inevitable destiny.

## *Context*

In what I'm sure will be a not very surprising revelation,
I'm a big supporter—believer, fan, advocate—of podcasts.
I think they're a great way for us to communicate and keep in
touch, share ideas...it's just a fascinating technology and I listen
to a number of podcasts in addition to making these podcasts of

my own. But also recently I've taken to downloading some radio programs via a neat little piece of software called Radio Time that allows you to record *real time* off of the Internet broadcast of various radio programs for listing to later. A little bit of an asynchronous radio listening experience, so that something that is being broadcast in a completely different location at a completely inconvenient time can be listened to on my MP3 player later. It's a neat idea, but here's a fascinating observation about it.

When I listen to these radio broadcasts over the Internet via MP3, they are real-time radio broadcasts—that is to say, they include all the commercials. All the other podcasts that I listen to don't include any commercials at all, and in the context of listening to a podcast, I find those commercials absolutely irritating. It is fingernails on a chalkboard to have to listen to five minutes of commercials in between the content, which is just not what we're supposed to do when we listen to podcasts! They are supposed to be pure, 100% commercial-free content. Well, at least that's what I've become used to, and that's what I prefer listening to. Now, the reason I bring this up is because it shows the importance of context when we're thinking about and looking at something from a consumer's point of view. Commercials in the context of a radio broadcast are, well, at least endurable. Commercials in the context of a podcast, however, are a completely different thing. The context influences the perception of the content. So when we look at fine art photography, for example, the context within which we are viewing it makes all the difference in the world.

When we look at a photograph in a book, we expect a certain tonal range, a certain paper, a certain look and feel to the aesthetic experience of looking at a photograph. When we look at one framed on the wall in an art gallery, we have a completely different expectation, simply because of the context. Our eyes are constantly shifting. One of the ways that shows up is that our eyes are constantly adapting to color. I explained to my daughter the other day how indoor or incandescent lights tend to be somewhat orange, because she was finding these odd colors in

the photographs on her digital camera, because it wasn't white-balancing correctly. She had no idea that the color of light on an incandescent bulb was any different than outside because, of course, her eyes adapt to the color shift in the light and to her brain—it's just what is.

Context changes how we view things, and as photographers, as creators of artwork, this is such an incredibly important part of our a creative process, because it's so important for us to understand the context within which our artwork will be seen and possibly even that we need to control that context to a certain degree so the artwork can be seen in a certain way. Certainly content is king, but context should not be overlooked in its ability to determine how the work is perceived.

## *Context Part 2*

Yesterday I was talking about context as an important factor in the way that content is perceived, and today I want to expand that discussion just a little bit, because I want to provide a practical example of what I'm talking about. When I do my *Brooks Jensen Arts* folios, they are relatively small prints—that is to say, they're not intended to be seen as wall art, so usually they are 8x10 prints or smaller and I tend, these days, to make a lot of them inkjet prints. Well, in the context of a folio—a hand-held, hand-viewed fine art artist's book, if you will—a small print produced from an inkjet is a perfect context to see that medium. It looks just exactly the way it's supposed to look in that context. On the other hand, if I were to take those small inkjet prints and matte them and frame them and put them in a gallery, they wouldn't necessarily feel appropriate. They would look...well first, they'd just plain be too small, and in the second place, if they were in the context of a gallery that had an exhibition of my gelatin silver work, for example, the inkjet prints would look sort of out of place. They are a different tone; they are a different tonal scale; they are a different Dmax density; they are a different

paper-base. They wouldn't look right if there was, say, one inkjet print in the middle of a gelatin silver show. On the other hand, take an entire exhibition of large inkjet prints and a single gelatin silver print in the middle of that, then the single gelatin silver print would look odd. This is not a statement about digital versus analog. What it really is is a statement about media consistency, and I've seen this happen, where a gelatin silver print shows up in the middle of a platinum palladium exhibition or a platinum palladium print is in the middle of a gelatin silver exhibition. It just doesn't look right.

Well, going back to my folios… in essence, what I ended up doing was creating the context in which that kind of presentation of small inkjet prints would look right. So in some regards, you can take what you can produce and then design a context in which what you can produce can be seen that makes it look terrific. This may seem a little backwards. More typically, what we do is we take a venue and then we produce for the venue. What I'm suggesting here is an equally valid but completely opposite approach strategically, which is to take what you can produce and, if need be, invent a venue in which what you can produce or what you want to produce and what you choose to produce all looks terrific. Essentially what I'm saying is that if what you choose to produce, what you want to produce, or what you can produce doesn't look right in the standard contexts of your day, then invent a new context. Think differently.

I'll never forget the story of a guy named Norman Bushnell, who was the inventor of Atari and who made his first and primary fortune not the with Atari TV games, but by reinventing the pinball machine. He took the context of a pinball machine, which had a certain width left to right, and he simply expanded that a few inches—and in doing so, the angles and the nature of play of the pinball machine was so entirely different in that new context that he made something that was phenomenal. He changed the rules of the game; that is to say, he changed the context in which the game is played and it became an entirely different game.

We can do exactly the same thing in our artwork: change the context in which it's seen, and it changes how the work is perceived in its entirety. Far too often I find artists who are struggling mightily to make their art or creative vision fit some pre-existing template of a context that doesn't fit their artwork. They are trying to take something and put it on a gallery wall that just doesn't belong on a gallery wall. Change the context of presentation, and you might find that such struggles just evaporate — and your work finds a home in which it is perfectly comfortable.

## *Majoring in the Minors*

I was reminiscing the other day about my early days in photography, and I remembered how I was taught to matte and mount prints. In those days, we were taught that you should take the gelatin silver photograph and dry-mount it to a piece of backer board, which was then trimmed to ever so slightly larger than the image size itself. So an 8x10 print was mounted on maybe a 9x11 piece of cardboard. That piece of cardboard would then be affixed to the back side of a beveled, window-cut matte that might be 16x20 or something. So in essence you had this little tiny piece of cardboard affixed to the backside of a much larger piece of board. The reason I bring this up is because the method of affixing the small cardboard to the large cardboard contained an interesting story.

We were taught that the way to do that was to be fastidious — absolutely meticulous in how the cardboard was attached — because even though no one would ever see how you attached the back cardboard to the front cardboard, it was an indication of your spirit in how you approached your creative process. Of course there may actually be some logic in this teaching — that you want your students to be careful about what they produce and to pay attention to detail and to have that spirit manifest in what you are creating. I can't argue that, but most of us completely misinterpreted the lesson, because we instead

thought this was a lesson about matting and mounting prints, and we paid attention to the wrong details.

I suppose it's not unusual for students to miss this kind of a point. Now the reason I bring this up is because I think it is part of human nature to focus on the details and the specifics to the exclusion of the big picture, and this is illustrated by this particular story because that's exactly what we did. We were taught that you affix the backboard to the window matte board with masking tape, so we would pull off these great big long strips of masking tape, lay them down on the edge of the board, and tuck it in real nice with a bone burnisher to make sure that the masking tape was affixed very solidly. We would have all four sides of the small cardboard so that it was taped very securely to the matte board. Now here's where the silliness comes in. We were then taught that where the joints of the two strips of tape crossed each other in each of the corners, we were to take an X-Acto blade and trim those loose edges so that they were perfect, perpendicular, right-angle squares of tape. No torn tape on *our* mattes! If we had torn tape, we were actually reduced a grade level, because that showed we didn't really care about our artwork with the fastidiousness with which we were supposed to care about such things. Never mind that we were taught to use masking tape. Never mind that we were taught to tape something together as though the tape itself was going to last forever. Of course what eventually happened is the masking tape dried out, the prints all fell off the matte board; it was a terrible way to do things. But there is a mindset I think this represents that I've seen in various other ways of photography, and that is what I call majoring in the minors—taking some little teeny tiny detail of production and putting so much effort and energy into that little tiny detail that you sort of lose sight of the bigger picture.

I'll never forget the time I bumped into one of my ex-fellow students from back then at a photography opening of his work and he had these giant prints on the walls of the gallery and he was rather distraught that no one was buying any of his work.

It was beautifully done. It was absolutely spectacular! But I mentioned to him, *Has it dawned on you that no one is buying your big 20x30 prints because you've made these really colorful pictures of roadkill? Who wants roadkill pictures in their home or their corporate office?* He had missed the big picture. For the small picture, they were spectacularly done. I mean the technique that he used was gorgeous! But it was not likely to be wall art. This is, again, an example of majoring in the minors.

I guess what I'm suggesting is sometimes a little perspective helps. Step back from what it is that we're doing and see if it makes sense from a slight distance instead of getting so hung up in the details and the craft and the production of what we're doing that we fail to realize that what we're actually producing is sort of silly.

Needless to say, I'm glad my masking tape days are long over.

## Finding the Time to Create

I was once advised by a friend of mine that the process of getting older is the process of letting go. She was in her mid-'60s at the time and I was in my mid-'30s, and at the time I'm not really sure I understood her advice other than maybe on an intellectual level, but as I've gotten a little older I've begun to understand more what she was talking about. I was reminded of this last night when a friend came over for dinner and in the course of normal dinner conversation the question came up, *what are you reading these days that is interesting?* We were discussing the various photography magazines and websites that we visit, etc. — sort of a comparison of input, if you will, and he said, *well, interestingly enough, I'm reading War and Peace by Leo Tolstoy,* and I thought, first, how strange that I would have a friend who would be reading *War and Peace* and second, I thought, how strange that I myself had picked up *War and Peace* just a couple of weeks ago and had started to read it. He's slightly farther along than I am, but here we are, coincidently, out of the clear blue sky, both reading this novel,

written in the 1800s by a Russian novelist, generally considered by many to be the greatest novel ever written. It may or may not be the greatest novel ever written, but the fact that a lot of people would say so certainly means that it's an important novel and one that is probably well worth reading. That doesn't mean it's going to be easy. It is also, shall I say, a somewhat daunting 1400-page novel about the Napoleonic war in 19th-century Russia. What a strange thing to be reading. So we started talking about that, and he said—almost a direct quote that he could've taken the words right out of my brain—he said, *you know it's been on my list of stuff I think I should read that I want to read that's one of those things that I just have looked at for years and years and years and never gotten around to reading it and I thought* he said *that if I were ever going to do it, I better do it, you know, sooner rather than later, because time is running short.*

Now he's in his late '50s and I'm in my early '50s, but I had exactly the same feeling, that as we get older we don't have time for all the things that we would like to do, and so it's time to prioritize and get done those things we need to get done, and of course the conversation almost immediately evolved to *what about photography* because we're both feeling the same thing: that there is (in the term they use in economics) an opportunity cost to all the things we do, and by opportunity cost, for those of you who are not familiar with that term, I mean the things that you give up because you choose to do the things that you are doing, and we both had sort of come to that conclusion in our lives that, for example, when you decide to watch some TV sitcom in the evening, there is nothing wrong with that, but the opportunity cost is that you can't spend that same time reading *War and Peace*, working in the darkroom, doing whatever else you could be doing with your time…and as you get older and you realize more and more that your time to create and to produce and to think and to read and all the things you want to do in life—climb a mountain, take a trip, meet some people—that time becomes limited and so you decide you're going to let go of certain things in order to do other things that are more important to you. We had both

decided to let go of certain activities, certain TV shows we are watching, certain websites we are following, because instead we wanted to focus our lives, at least for this period of time, on reading War and Peace. I find it useful to remind myself of this concept whenever I start feeling like there isn't enough time in life for me to do my artwork.

There *is* enough time in life for me to do artwork. We all have the same 24 hours in every day. It's just a matter of how we choose to use our time. We can choose how we use those 24 hours: we can use them doing the things that are unimportant in our lives that make it seem like we don't have time for the important things, or we can choose to do the important things and let go of the things that don't count, that don't matter, that don't concern the production of our artwork or whatever it is that we prioritize in our lives. When the opportunity cost of doing something becomes too great and we let go of those things that aren't important and choose in their stead those things that are important to us and that we want to do, we find that we have all kinds of time that we didn't know we had, because we were focused on the unimportant things.

## *My Philosophy of Art in a Nutshell*

I'm not sure that you may have noticed this, but there are no books, no workshops, no college courses, no seminars, no television programs that teach us how to be pessimistic or dour or grave or depressed. No one needs to be taught how to be pessimistic — it comes naturally to all of us. Life is difficult, life is hard, and therefore it's natural for all of us from time to time to be pessimistic and depressed and discouraged, so it doesn't need to be taught, but instead, what do we find? We find books on how to be optimistic, how to be encouraging. We find seminars on positive attitude, on being upbeat. It's the old *is the glass half-empty or glass half-full* sort of scenario and, interestingly enough, the news business that we read every day in newspapers,

magazines, the Internet, radio, television tells us all the bad stuff, which is what news is.

The reason I bring this up is because it bothers me a little bit, personally, that art—photographic art in particular—has, to a large degree, lost its way in many venues, and confused the purpose of art and the purpose of news. I see far too much of what I would consider pessimistic art, discouraging art, depressing art...photographic art that is intended to show us how bad the world is. You know, I don't need that. I know how bad the world is. I have a hard time escaping how bad the world is, because it's thrown at me every single day from all kinds of news-oriented venues. Art, in my way of thinking, has a purpose to do just exactly the opposite. If we don't need to be taught pessimism, we don't need art to show us the bad side of life, the bad side of the news of today's society. The ills are everywhere, and when photographic artwork tends to focus on that side of life, I think it's missing an opportunity, or the photographers are missing an opportunity, which is the hard part in life, which is to maintain one's optimism.

We all need to be shown and reminded and taught and encouraged and motivated and emphasize the glass being half-full, because that is, at least in my way of thinking, the purpose of art. The challenge of life is to not let, you know, as they say, the bastards get you down. To take our intelligence and our passion and our creative spirit and to see the positive. To move forward, to move ahead in improving life. Now that doesn't mean, you know, a blind eye to the world's ills. We don't need to be ostriches with our heads in the sand, but when it comes to art and the production of art and the enjoyment of art and surrounding ourselves with art, I continue to think that the purpose of art is to uplift the human spirit, not to discourage it. It's to motivate us to strive to higher levels and to find the good in each other and in life in general, not to remind us how difficult things are. We don't need to be reminded how difficult things are. They are difficult enough. So when I see so much of that kind of pessimistic sort of approach to photography, it just turns me off.

Recently a magazine published an issue for their holiday issue—their Christmas issue. This is a big important magazine, and the entire magazine was filled with negative imagery. Drug dealers, war pictures from Iraq...you know, I know there are drug dealers in the world. I know that there's a war in Iraq. I know there is suffering, but somehow I can't help but think that art photography—and this is an art photography magazine, not a news photography magazine—I can't help but think that art photography has a role to play. I might even say, a *responsibility* to play, to help to share the vision that uplifts humanity by focusing on the glass-half-full aspect of life rather than the other way around. Now I'm not naïve, and I know there are probably many of you out there listening to this podcast who will disagree with me, who think that one of the roles of fine art photography is to show us the real side of life, not the Pollyanna side of life, and somehow that idea—that the negative in life is more real than the positive in life—has always escaped me philosophically. The negatives may surround us, it may be more present, life is, after all, suffering, as the Buddhists say, but that does not mean that that's where our focus of attention ought to be. It doesn't mean that looking at the encouraging and uplifting side of life should be abandoned by artists in terms of something that's more "real."

Artists throughout history have accepted the challenge and the role to explain and show and illustrate what cannot be readily seen. Artists are those people who are gifted to see what escapes other people's attention. In this regard, the historical role of the artist is to be more akin to the mystic than to the newspaper reporter, and if society at large has a tendency to see the negative, depressing, pessimistic, difficult, quote-unquote realistic side of life, then even more so the responsibility of artists is to show what can be, what could be, to show what is possible through the positive aspects of the human spirit, and to do and to show and to illustrate what others may not be able to see because they are so surrounded by the difficulties of life. Some may call this a sort of Pollyanna attitude. In my way of thinking, it is ultimate-

ly a pragmatic point of view, because it provides a kind of tonic against the normal difficulties of life. It's a medicine that helps us  potential of life and the goodness that exists in us and all that surrounds us rather than focusing on the difficulties, the barriers, the problems, and those things that tend to drag us down.

Art is not philosophy, and I know that in this podcast I've probably danced right across the line that separates the two, but philosophy, outlook on life, the way we choose to interpret what goes on in the world, all does have an impact on our artwork and how we choose to create our artwork and, even more importantly, what we choose to surround ourselves with in terms of artwork in our everyday life. For me, it's those artists and those visions that encourage and motivate and try to illuminate the better side of the human spirit and those things that propel us to achieve and to demonstrate compassion and love and the positive aspects of life that are the ones that are the most interesting, most useful, most encouraging, most motivating. We each make these decisions, of course, for ourselves, but for me, I choose to focus my energies, surround myself, and create the kind of artwork that focuses on the best in human nature. I find I don't need to focus on the negative side of life in order for it to surround me naturally, but I do need to focus my energies on the positive side of life, or it would remain invisible. The discouraging and the depressing is a copout—an easy path. It's much more difficult, both as an artist and as a human being, to stay focused on the positive in life, because that takes effort, and that's the way I choose to make my artwork and the way that it makes most sense to live my life.

## *The Next (Difficult) Frontier*

As a result of my editorial in *LensWork* #67, I received a very interesting e-mail from a reader named Andrew Payne, and I've asked Andrew if I can quote his e-mail and explore

the question that he asks, and he's agreed, so I'd like to read you his e-mail. He says:

"Dear Brooks, thanks for your thoughtful editorial called "The Tsunami On The Doorstep" in *LensWork* #67. Your note is a great exploration of what could happen as things that were technically hard become easy. Here's another angle," he continues; "as photographic technology progresses, what's the new hard? Back in the very beginning one needed a high degree of technical skill to make any photograph. As a result, photographs of anything were rare, unique and coveted objects. Then, as time progressed, more technology became accessible to the masses and anyone could make a picture. The rare hard skills got pushed out to the niches. Large formats, large prints, special exposures, manipulation, etc. Today things have shifted once again. The digital darkroom has made easy what was once hard, so the logical question to ask is, what's the next technological frontier that will enable amazing things?"

Now I have to tell you, I think Andrew's question is absolutely fascinating. He's right. He's absolutely right. There will be creative individuals who push the envelope. There always have been. There always will be those who find something that's incredibly difficult to do and they will explore that as their creative path. His question, what's the new hard, is one that, I have to be honest, escapes me. I don't know. I don't have the foggiest idea, but I am very interested to see what the answer to that question is, and I suspect there are probably some of you out there who are exploring it as we speak. I've felt for some time that the next new hard in photography is the true potential of photography, and that is exploring the human soul. Creating, in photographs, great passion which has nothing to do with technology — but I may be entirely wrong in that. There may be a new technology that will show us things we can't possibly imagine today, and isn't that an exciting prospect?

# *The 60-Second Monet*

A friend of mine was recently telling me about his experience visiting an exhibition of Monet paintings at a major museum. There were about 50 paintings, and obviously it was a very popular exhibition, so the museum had the foresight to sell tickets to see the exhibition on a timed schedule. As it turns out, visitors were allotted about an hour to see roughly 50 paintings. Such a statement, of course, leads one to immediately want to do a little math, and you realize that he had about one minute, 60 seconds, for each Monet painting, and that got me thinking about how long is enough time to look at—particularly a masterpiece—a Monet painting?

Minor White used to say that it was a good exercise to look at a photograph for 30 minutes. To just stare at it for 30 minutes. Look at it, search, examine your emotional responses to the photograph, etc. So obviously, his opinions were sort of at the opposite end of the spectrum from the museum that had the Monet paintings.

I remember once, Morrie Camhi telling me that he and some students had done an experiment where they watched people go into a photographic gallery and timed how long they were in the gallery, from the moment they walked through the front door to the moment they came out of the front door, and did some math, and discovered that the average person spent about 10 seconds per photograph in the gallery. I suppose my friend could at least be excited that he was allocated six times that for each Monet painting. Obviously I don't know how long is the right amount of time to spend in front of a piece of artwork, but it seems to me that if the artwork is interesting enough, meaningful enough, speaks to you enough, that perhaps it's more than 10 seconds and possibly longer than 30 minutes. And the one thing I do know for sure: that we spend too little time with artwork rather than too much, and the fact that museums and other institutions would promote that sort of instantaneous *look at it,*

*you've got it, move on to the next one,* that seems to me to, shall I say, insult the artwork as well as the viewer.

## *The Pursuit of Excellence*

When I was in my '20s I worked for a large corporation, a big retailer up here in the Pacific Northwest, and was singularly focused on business for pretty much that decade. I still did personal photography, but my '20s were primarily a time for me to learn about the big wide world of commerce, and one of the things that I learned, interestingly enough, was the difference between *commerce* and *art,* and for years I've sort of abbreviated that life lesson by saying that business is something that we do with the least possible effort and for the maximum possible return on investment — that is to say, you don't make a product any better than you have to because if you make it better than the customer expects or wants, anything beyond that is just waste. So you try to provide, in business, exactly what the customer wants, and no more. You find that fine line where it's acceptable, and you can make a profit. Whereas art, on the other hand, is a completely different kind of human activity.

Artmaking, or in my case photography, is something that I pursue regardless of any customer expectations, and in fact the last thing in the world I want to do is stop when it's good enough. Art is the pursuit of excellence regardless of cost regardless of time, regardless of effort, regardless of any external consideration like that, at least for me. Artmaking is nothing more than the single-minded pursuit of excellence regardless of the cost and regardless of the implications about commerce. You don't care whether or not you make any money on your artwork because you're pursuing excellence, not profitability, and for the longest time I've thought about that and quite honestly, what *LensWork* is for me is sort of a bridge between the two. It's something that I can use my art mentality with. I can pursue excellence and push it as far as is possible and still try to make a viable

commercial business. So *LensWork* to me became sort of an escape from the world of mediocrity in business and allowed me to bring some of that pursuit of excellence into commerce. It was a hybrid in between. It's the pursuit of excellence that I think is so important in all of this, because the one thing that defines artmaking is the pursuit of excellence at all costs.

I think about this every time I'm out with a camera, or printing, or putting together a show, or trying to put together a portfolio, or whatever the case may be. The question—the overriding question, the dominant question, in fact the only question—is, how can I push this to something even better? Can I push the definition of excellence beyond what I currently expect? And what that implies, obviously, is as one goes through their career and gets older, in art, excellence becomes a loftier and a more difficult thing to achieve, because you keep raising the bar.

Part of the reason that I bring this up in this podcast is because, quite honestly, I have some concern that that way of thinking, that idea about pursuing excellence, is considered archaic, and when I see a lot of what's going on, particularly in contemporary pop photography, if you will, I don't see the pursuit of excellence. What I see is the pursuit of commerce. People aren't making photographs to see how good they can make them but to see how much money they can make *with* them. It's not a question of how good can we make the book or the exhibition or the portfolio, but rather how much publicity we can get with it, how cheaply can we make it, and how can we price it so we can maximize the profitability and the return on investment?

When commerce starts to leak into art, I think it diminishes art; and similarly, when commerce starts to drive the motivations and the production logistics of photographers, it diminishes the photographer. That's not to say that we shouldn't be selling our work. That's not to say that there is no room for commerce, but it's excellence that ought to be our standard, excellence that ought to be our motivator, and excellence that ought to be the reason why we're doing our art—not profitability. I wish this

was a lesson that was more universally taught in art schools and to young photographers and maybe by mentioning it here I can get people to think about how they define excellence and how it is that they strategize, as it were, to pursue excellence as the core of their artmaking activities. In my way of thinking, art without the pursuit of excellence is not art. It may be interesting, but it's not art, because art is the pursuit of excellence, and any other definition of artmaking, I would tend, at least for me personally, to want to reject.

## *The Big Combo*

It's been a while since I recommended a movie, but I have one I'm not recommending, I'm *insisting* that you see, because it is so good! It's not such a terrific movie because the movie is good or the plot is good or the acting is good, although all of those are certainly adequate. It's for the lighting. It was a movie that was recommended from a documentary that I was watching on cinematography and I have to be honest, I did not realize that one of the main tasks of a cinematographer was lighting, and this documentary went on and on about lighting in Hollywood movies and what masters they are at lighting a scene. Well, obviously that's something that is of keen importance to a photographer, and as I've mentioned in other podcasts, I'm starting to play around more with artificial lights, and so I was interested in cinematography and the use of lighting to light a Hollywood a movie scene. Well, the movie that was recommended in this documentary is called *The Big Combo*. It's a film noir movie from 1954 and like a lot of film noir movies, it's (obviously) black and white and it's about crime and policemen and the good guys and bad guys and all that stuff, starring Cornel Wilde and Richard Conte and Jean Wallace—people who are not A-list actors, or at least not actors we probably know about now, but they are recognizable faces. You will probably recognize them when you see them on the screen. The most important person in the film, however, from

my perspective, is the cinematographer, a fellow by the name of John Alton. He did an absolutely spectacular job of filming this film noir movie in black and white and in particular controlling lighting. It is a film that you could watch with the sound turned off and just watch the lighting in the movie over and over again and probably learn so much. The angles of lights, the direction of lights, the intensity of lights, the contrast between light and dark, the way he uses light to create mood and to illuminate details. It's absolutely spectacular! *The Big Combo*—it's available via Netflix, which is where I got it, and I would recommend it to anyone who is interested in black-and-white photography and in particular artificial lights.

# *The Hyper-World*

Okay, so now it's time for your 20-point toss-up question. What do Pamela Anderson and Ansel Adams have in common? Let me repeat the question. What do Pamela Anderson and Ansel Adams have in common? [Humming the Jeopardy theme...] Your time is running out. [More Jeopardy theme humming.] The answer is, they are from the hyper world. What do I mean by this? Pamela Anderson does not look like any human being I have ever known or personally seen anywhere in any context whatsoever other than in Hollywood. Hollywood tends to make us appreciate hyper people, hyper beauty, hyper masculinity as we see it in virtually every action adventure film with Arnold Schwarzenegger or 007 or someone like that. Hollywood tends to take the real world and stretch it with hyperbole into unreasonable and untrue proportions that are, well, if nothing else, entertaining, but they're not real. Everything about Pamela Anderson is real life blown up to bigger and bigger proportions, no pun intended. Well, okay, maybe a little pun intended.

Ansel Adams is kind of the same way. I've stood on Wawona point and looked out at the valley of Yosemite, and it did not look like his photographs. His photographs have a tendency to

present us with a hyper world—a world which doesn't exist but
sort of *could* exist. Now I'm not casting stones at Ansel Adams,
because at least he photographed things that really were there,
and he enhanced them through photographic skill to make
them look even more spectacular than they may have been in
real life. And I'm contrasting that—which seems to me to be
perfectly acceptable, it's sort of what photography is about in
some regards—to a new book by Joan Fontcuberta published
by Aperture called *Landscapes Without Memory*. In this book, he
has taken a piece of software called, I believe, Terragen, and he
has created hyper landscapes. Mountains that don't exist but
look absolutely spectacular. Rivers and waterfalls and lakes
and colors and valleys and you name it—things that don't really
exist in the world but look as though they could. They are photo-
graphically real, but they are all fake. They are all constructions.
They are from a hyper world. They're all put together artificially,
not by, as it were, the hand of God, but rather by the hand of
the machine—sort of like Pamela Anderson. And this intro-
duction of the hyper world into photographic art makes, quite
honestly, very, very captivating and very interesting landscapes,
and at the same time, it really bothers me because somehow,
I can't help but think that such a focus on the hyper world
diminishes the real world.

When we are constantly titillated by the likes of Pame-
la Anderson, somehow that makes real women seem...not as
spectacular. When we're titillated by the hyper landscapes of
Ansel Adams, somehow Yosemite is...almost a disappointment.
And in particular, when we look at these constructed artificial
computer-generated landscapes in the book *Landscapes Without
Memory*, does it make regular landscapes seem somehow wimpy
or pathetic or less spectacular? This is one of those philosophical
questions that are likely to plague us for some time and prompt
lots and lots of discussion and chat-room debates, etc., on the In-
ternet, but there is something about the application of a pho-
tographic skill or computer skill that diminishes our apprecia-
tion of the real world. That seems, somehow, going in the wrong

direction for me. I've got more to think about here, but that was sort of my first take, when looking at this book.

## *There's Grey, and Then There Is Gray*

Okay, so it's probably not a big surprise that human beings are different from one another—I suspect that's probably a lesson we all learned a long time ago. But here's an example of that lesson learned again, and this time I'll tell a story on myself.

We published a selection of images from John Sexton's new book *Recollections* back in *LensWork* #66, and we received his new book the other day. A very nice gift from John and Anne and I was pleased to get it; it really is a spectacular book. If you like John Sexton's work, this is definitely a must-have for your library, but obviously one of the first things I did was to sit down and compare his book to the reproductions that we did in *LensWork*. There's one very obvious difference between the two reproductions: the duotone that was used to print the images in his book compared to the duotone used to print the images in *LensWork*.

We use a slightly warm duotone and that tends to give just an ever so slight brownish look to all the images. We do so, quite honestly, because I have always felt that slightly warm images tend to be more three-dimensional to my eyes. They just look different than a cool-toned or a neutral-toned image. Now what's fascinating about this, and the reason I bring it up, is because we were looking at it here in *LensWork*. The staff was looking at the comparison between John's book and *LensWork* and it was very, very interesting to me that some of the staff had exactly the opposite experience. They compared the two images and found that the cooler tone in John's book looked more three-dimensional to them than the warm tones in *LensWork* did. And this reminded me of a conversation I had with a friend of mine, Ray Maxwell, who is a real color expert, and as a matter of fact we're going to be doing some conversations about color in an upcoming

issue of *LensWork Extended*, and Ray was telling a story about
taking a series of test gray patches that were 50% gray but very
slight colors — one was 50% gray but slightly blue and another
was slightly orange and another was slightly green, slightly cyan,
slightly red, etc. So he had sort of a grid of grayscale patches that
were all slightly different colors, and he took them into a print
shop and asked the staff at this high-end print shop to identify
which patch was absolutely neutral gray, that had no color tint in
it whatsoever, and what he discovered in this little extemporane-
ous experiment was that all kinds of different people chose all
kinds of different patches as being the one that was dead-neutral
gray, and there were even some identifiable gender-trend differ-
ences; women tended to go to one end of the spectrum, men to
the other, although obviously there were exceptions.

The bottom line is, people are different, and everybody sees
black and white and sees the tonalities in black and white slightly
differently. I like warm tone. I'm going to continue to do warm
tone because it pleases me, but obviously in making that choice,
I know from our little experiment here last week with John
Sexton's book that when I make that choice to do warm-tone
photographs, for my personal work or for *LensWork*, that I am
probably making images that are not optimized for some viewers
and are perfectly optimized for other viewers, and that's just sort
of the way it is because, as I began this podcast, people are dif-
ferent. What a surprise.

## Making Dark

A few days ago I talked about a movie called *The Big
Combo* — a film noir flick that I particularly enjoyed because of
the cinematographer John Alton's use of lighting — but the more
I've thought about this, I've had a different take on it. I still think
the movie is fantastic, but I've watched it a couple of times now,
and the last time I watched it I remembered a very brief moment in
my youth when I studied calligraphy and the calligraphy teacher

taught us to not watch the ink as it flowed onto the paper from our pen nib but rather to watch the paper—to watch, in particular, the edge of the paper as the ink made a contrast line against it. So there was sort of a yin and yang flip going on, because the natural tendency, obviously, when you're writing with ink, is to watch the ink. He suggested it was more productive to watch the paper.

Well, the same can be said of photography. It seems like what we do is control lighting, but you know, as I've watched *The Big Combo* over and over, I realize it's not lighting that is being controlled. It's shadows that are being controlled. Obviously the shadows are made with lights. Obviously the letter is made with ink from the nib of the pen, but the effect one is trying to create is not the ink but the paper. Not the light but the shadow. With this in mind, I'm anxious to get back in the studio and start photographing to see how I think differently when I start looking at what is more or less painting a photograph by painting shadows through the control and manipulation of the artificial lights.

I suppose in a very fundamental and physical way this makes sense, because the photographic paper—be it in the darkroom or with an inkjet printer or whatever—the paper is white. So what we are actually creating are the shadows that give us the illusion of light—that is to say, what we actually make photographically is darkness. I don't think my brain works that way naturally, but I have a suspicion that it could, and that it might be very interesting to do so.

## Internet Photography Docent, Where Art Thou?

A quick trip around the Internet will show you lots and lots and lots of websites that discuss the equipment of photography, but I'm fascinated that there are very few—as a matter of fact, I'm not sure I've found *any*—websites dedicated to discussing

photographs. I hope there are some and I hope if you happen
to know them that you'll let me know, because I would find
that a fascinating thing to visit on a regular basis. But it's very,
very hard, or at least very, very unusual, for people to talk about
photographs. And that brings me to, I think, one of the most
important roles that each of us have for our own photographic
work, as it were, and that is the role of the docent — the person
who has to sort of explain the photographs.

Now there's a long tradition in photography, particularly in
classic black-and-white photography, that if you have to explain
it, it's somehow, you know, not right. You shouldn't have to
explain a black-and-white photograph. It should be self-explan-
atory, as it were, and seen outside of any contextual explanation.
For a long time I've sort of argued that that's an intellectual point,
but not true. The classic way I've illustrated this in articles that
I've written is that the title of the great Dorothea Lange image,
*Migrant Mother*, tells us context about who this person is that
we're seeing , and if instead that image was entitled *Waiting For
The Returning Soldier*, we'd have a completely different view of
that image. So the context in which an image is seen — that is
to say, in particular the story behind it — is the role of the docent,
to communicate the backdrop that is so crucial in determining
how an image will be seen and viewed and understood. Each one
of us as photographers needs to realize there is this responsibility
to be a docent for our own work. Or maybe someone else needs
to be the docent for our own work, but that seems to be not a very
practical solution, because I can't find anywhere on the Internet
where anybody is a docent for anybody's work.

What fascinates me about all of this is that it is so impor-
tant to understand the context of a piece of work and to have
the fundamental understanding of what the work is about in
order to plumb it more deeply — that when we are left without
that fundamental understanding, a lot of times our appreciation
of a photograph is a lot more superficial than it could be, or than
it should be, and to explore the depths of a piece of artwork, be

it a photograph or a painting or anything else, it is handy to have that explanation that helps us go more deeply than our surface reactions. How that comes about with photographs is as varied as there are photographs and, I might add, as varied as there are means to show and exhibit photographs, but nonetheless, when that docent role exists and somebody steps up and says "let me offer an explanation of this work," it makes it more accessible. I sure wish somebody was doing that on the Internet because I think it would be fascinating.